IMAGES
of America

JACKSON TOWNSHIP

D1190658

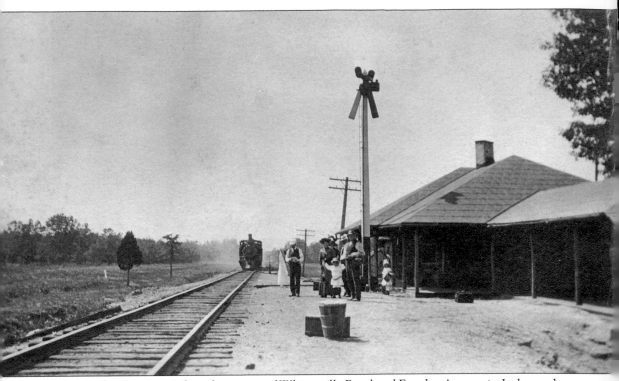

ON THE COVER: Located on the corner of Whitesville Road and Faraday Avenue in Jackson, the South Lakewood railroad station provided connections to New York City to the north, Philadelphia to the west, and Atlantic City to the south. In this c. 1900 image, area residents await a train. (Courtesy of Jackson Township Historic Commission.)

IMAGES
of America

JACKSON TOWNSHIP

Victoria O'Donnell and
Christopher Ippolito

ARCADIA
PUBLISHING

Published by Arcadia Publishing
Charleston, South Carolina

Printed in the United States of America

Library of Congress Control Number: 2012933986

For all general information, please contact Arcadia Publishing:
Telephone 843-853-2070
Fax 843-853-0044
E-mail sales@arcadiapublishing.com
For customer service and orders:
Toll-Free 1-888-313-2665

Visit us on the Internet at www.arcadiapublishing.com

This book is dedicated to those who have documented and preserved the history of Jackson Township for current and future generations.

To Gerard, Andrew, and Aidan . . . your support has meant the world.

—V.O.

To Brigid, Reagan, Ryan, and Fiona . . . thank you for your love and support.

—C.T.I.

CONTENTS

ACKNOWLEDGMENTS

History with its flickering lamp stumbles along the trail of the past, trying to reconstruct its scenes, to revive its echoes, and kindle with pale gleams the passion of former days.

—Winston Churchill

As we began our journey creating this book, two well-respected residents were not only eager to assist us, but they provided their support throughout this endeavor. This project would have been impossible without the help of Bernie Reider and Daniel J. Black. We are extremely grateful for the meetings with residents, tours through town, and the many phone calls they have accepted answering our questions. Many of their hours were spent gathering photographs and introducing us to longtime residents who trusted our motives because of them. Jackson history is being told through these pictures because of these two gentlemen.

The Jackson School District has been extremely supportive in stoking our passion for history. We appreciate the support and encouragement, beginning with Kevin DiEugenio, our former principal. Equally supportive is our current administration team, principal Rob Rotante and vice principals Debra Phillips and John Kossmann. We thank the members of the board of education and our central administration, including Thomas Gialanella; Stephen Genco, EdD; and especially Lu Anne Meinders, who has been a great source of guidance throughout this project and many others.

We are thankful to have the support of our local government, the township council, and Mayor Michael Reina, who has supported this project from the beginning. To the past members of the Jackson Township Historic Commission, David Miller, John Smatusik, and Katherine Debow-Redlich, we are grateful for their dedication in preserving our past. We have learned more about this town and are grateful for the stories they have shared, the pictures that were taken, and the time they spent throughout their lives bringing our local history alive. We thank Alexander Platt for the many articles he has written and the talks he gave about Jackson history.

Oral histories gathered from longtime residents were a valuable asset in bringing these pictures to life. Thank you to Steve and Eileen Lambert, Wally and Marge Jamison, Gene Hendrickson, members of the class of 1966, Peter Wolanansky, Rev. Fr. Alexander Smida, Bill Weitzen, Pat Wood, Theresa Holman-Vives, Jason Wickersty, Jackie Cottrell-Burns, Dolores Kraft-Regnault, Hilda Lindauer, Dana Clayton, and Verna Sprinkle. Special thanks to Howard C. Johnson, a man so dedicated to education that he continues to teach long after his time on Earth. In addition, we would like to thank William Bricker of Rands Camera for scanning photographs. We appreciate the guidance of Abby Henry of Arcadia Publishing on this project.

We would also like to recognize the late Lorraine Applegate for the photographs of Jackson Mills. The chapter on the Jackson Township Police Department would not have been possible without Borden Applegate. Throughout his tenure at police headquarters, Applegate documented its history, a trait he must have learned from his mother. Most Jackson Police Department photographs are provided courtesy of Maj. Borden Applegate (Ret.). We thank him for his willingness to share that history with us so that we are able to share it with our town. Also, we would like to thank Matthew Kunz, chief of police, for his support with this project.

We thank our friends, colleagues, and families for their continued support, encouragement, and patience throughout our journey. It is our hope this book calls attention to the need for historic preservation in Jackson Township and promotes the learning of our local history.

INTRODUCTION

Jackson's history dates back to precolonial times when the tribes of the Lenni-Lenape roamed what is today Jackson Township. Though they have long disappeared, their evidence is left as a reminder of a people who hunted and gathered, utilizing what was necessary from the land and traveling via local waterways. Artifacts such as arrowheads and cooking utensils remind us that this Native American tribe lived off the valuable resources of what is today our town.

Jackson was established as a new municipality in Monmouth County in 1844 and was annexed by Ocean County upon its establishment in 1850. Originally the area of Jackson included parts of Freehold, Upper Freehold, and Dover Township. It is said that George F. Forte drew up the boundaries of Jackson at Allen's General Store, now Art & Kathy's Kitchen, in Cassville. Forte was a physician, pharmacist, and postmaster who would later become the 16th governor of New Jersey and who petitioned the state legislature to establish the new town.

When discussing a name, it was proposed the town be named after Richard Mentor Johnson, the ninth vice president of the United States and a colonel during the War of 1812, who fought under the command of "Old Tippecanoe," Gen. William Henry Harrison. The decision was eventually made to name the town after the seventh president of the United States, Andrew Jackson, who became a national hero after defeating the British at the Battle of New Orleans in 1815. Some longtime residents disagree with this account and insist the town was named after William Jackson, proprietor of Jackson Mills. But evidence suggests the namesake was Andrew Jackson, considering that the section of town previously called Goshen and Downsville was renamed Cassville, after Jackson's secretary of war Lewis Cass.

The town of Jackson started as a handful of small villages, each with its own name, general stores, mills, taverns, churches, and one-room schoolhouses. These hamlets included Webbsville, Davisville, Leesville, Holmansville, Maryland, Irish Mills, Prospertown, Jackson Mills, and Cassville, the area's hub of activity. Well into the 20th century, residents would claim to be from these small villages rather than from Jackson Township.

Families were mostly self-sufficient, raising livestock, preserving fruit, and canning vegetables. For things they did not have, they would travel to the general store by horse and carriage and often utilize credit until harvest time. Those who did not toil on farms spent their days milling, making charcoal, and lumbering. Jackson's first cash crop was the cranberry. At one time, there were over 200 cranberry bogs in town.

The cranberry culture eventually declined, and the poultry industry became prominent in town. Chicken coops were built throughout the township; the second-largest poultry farm in New Jersey was located in Jackson. Egg farms peaked around 1950 but ended when the government no longer subsidized chicken grain. Feed cost increased as much as 300 percent, and the local industry could not compete with Delaware and Maryland.

Jackson Township has transformed in many ways. Industries have changed, schools have progressed, housing has been developed, churches have expanded, and public safety has adjusted to these changes. Our geography of the past is unfamiliar to newcomers of Jackson but our common history tells the tale of progress. Historic preservation is not without its challenges, and some feel preservation efforts interfere with progress. But as history educators, we consider preservation and history education as a path to the future, continually striving for improvement. It is our hope that you enjoy the images and it prompts widespread support of historic preservation efforts in Jackson Township.

One

EARLY PEOPLE AND PLACES

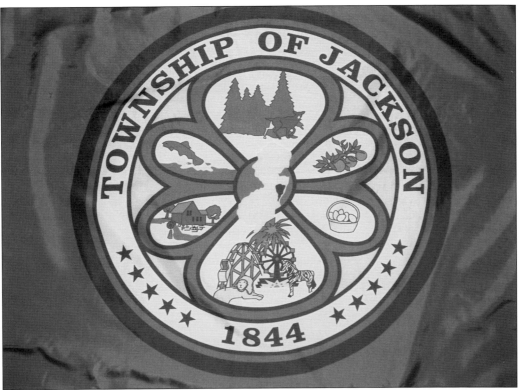

Jackson Township was incorporated in 1844 as part of Monmouth County, and six years later, it became part of the newly formed Ocean County. Shown here is the official seal of Jackson Township. The design incorporates community hallmarks, including an amusement park, a cranberry branch, a mill, a fish, a pine forest, and a crate of eggs. The center of the seal shows the township's position within the state of New Jersey. (Photograph by Victoria O'Donnell.)

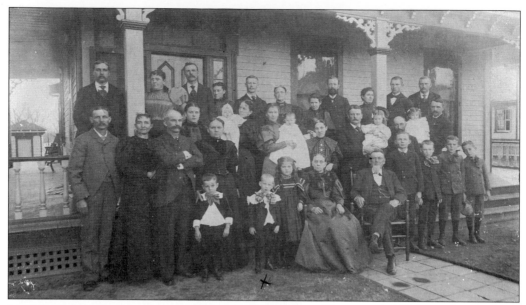

The extended Holman family poses around 1900 in front of the Holman Homestead. More than 30 family members gathered to be photographed in an era before smiling for the camera was fashionable. (Courtesy of the Holman family.)

De Young's
815 BROADWAY, N. Y.

The Holman family emigrated from Scotland in the 1700s, and Charles L. Holman was born in Jackson in 1830. Holman was one of the township's early cranberry moguls. He served nonconsecutive terms as Ocean County sheriff beginning in 1878 and served as a school trustee for more than a quarter century. (Courtesy of the Holman family.)

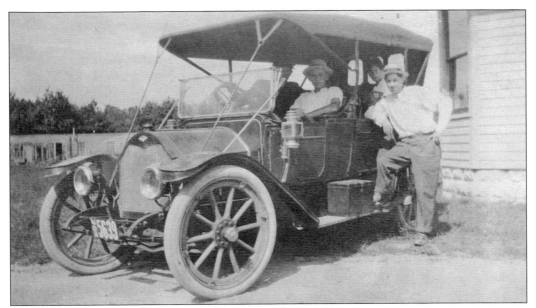

Several members of the
Holman family pose in 1914
in what was possibly one of
Jackson's first automobiles.
It would be decades before
cars outnumbered horses
in Jackson. (Courtesy of
the Holman family.)

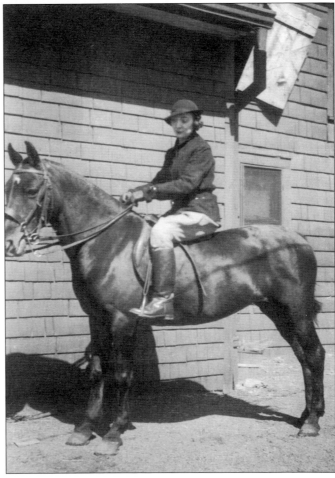

Lucy Holman's mother,
Muriel Negreval, poses on
horseback outside her home
in the early 1900s. The rural
landscape of Jackson made
for excellent riding. (Courtesy
of the Holman family.)

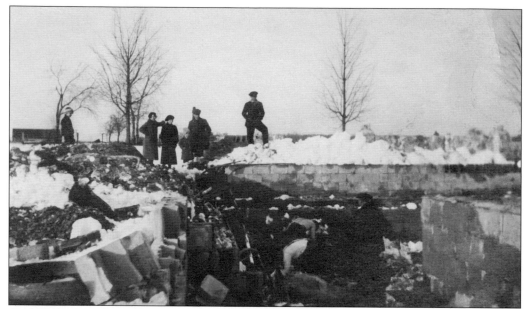

A 1914 fire caused significant damage to the Holman residence. The structure had been burned to its foundation. Shown here, family members and workers sift through the rubble in attempts to salvage whatever survived the blaze. (Courtesy of the Holman family.)

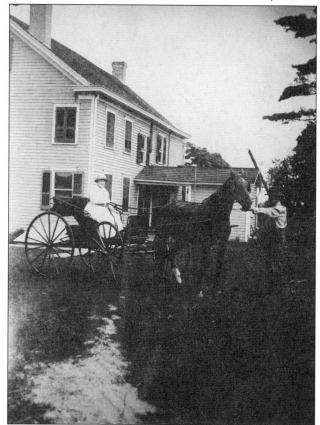

The horse-drawn carriage was the preferred mode of transportation in Jackson in the early 1900s. In this photograph, a man helps guide the horse down the path. The attire of the woman seated in the carriage suggests she may be headed to Sunday services. (Courtesy of the Holman family.)

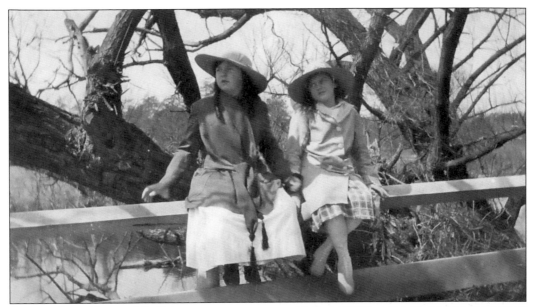

A young Lucy Negreval (left) is photographed in 1917 with Catherine Negreval, sitting on a fence at nearby Lake Carasaljo in Lakewood. Negreval would later become Lucy Holman, a longtime educator in Jackson. Holman Elementary School is named in her honor. (Courtesy of the Holman family.)

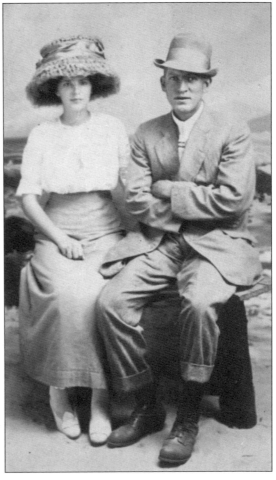

The Leming family was one of the original families that settled in Jackson Township. Pictured here are William Leming and his wife, Geneva Thompson Leming. Both William and Geneva were raised in Jackson near Burke and Leming Roads, an area known as the Maryland section of town. Many of the present roads in town are named after early families. The couple married in the early 1900s. The Leming family owned a general store on what is today called Diamond Road. Their family homestead was near the general store. Leming was a foreman for the Ocean County Road Department and played a key role in paving many of the township's dirt roads. Leming's grandparents came from Illinois by oxen-drawn wagons. His grandmother was a Native American. Leming descendants still reside in homes on Leming Road. (Courtesy of Geneva Clayton.)

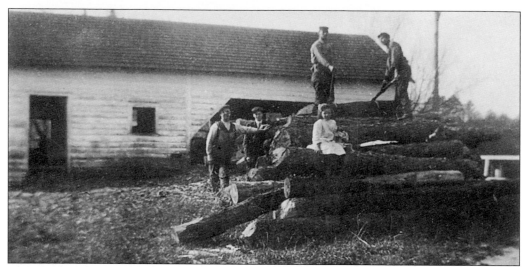

Like many of the surrounding communities in the 19th century, dozens of mills dotted Jackson Township's landscape. Lumber was a treasured and abundant resource, and many Jackson residents made a living in the local forests and at sawmills. The mills are long gone, but numerous street names and landmarks in the township reflect names of the families who operated them, including Bennett's Mills Road, Francis Mills, Colliers Mills Nature Preserve, and Jackson Mills Road. Even the Carl W. Goetz Middle School was named for a former Jackson Township sawmill owner. (Courtesy of Jackson Township Historic Commission.)

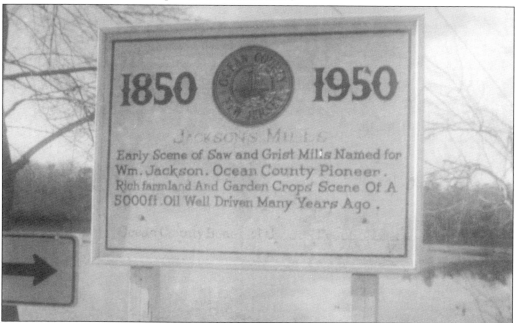

William Jackson was the well-known proprietor of Jackson Mills, a business that operated both sawmills and gristmills. Upon the establishment of the town, many residents believed Jackson Township was named in his honor, but others believe it was named in honor of Pres. Andrew Jackson. In later years, an oil well was drilled on the property but was quickly abandoned. This 1950 Ocean County sign commemorated the 100 years of Jackson Mills. (Courtesy of Verna Sprinkle from the Howard C. Johnson collection.)

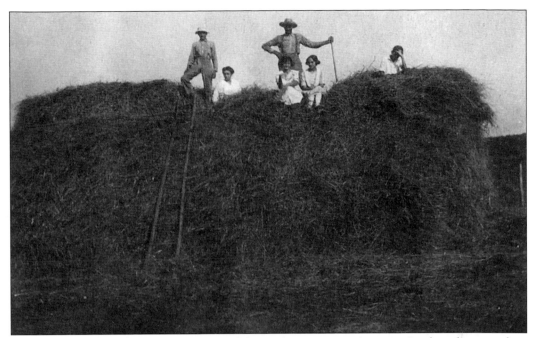

Farming was a family affair at the turn of the 20th century in America. In this photograph, a family enjoys a more leisurely day on top of an enormous haystack that probably took hours of backbreaking work to build. (Courtesy of Jackson Township Historic Commission.)

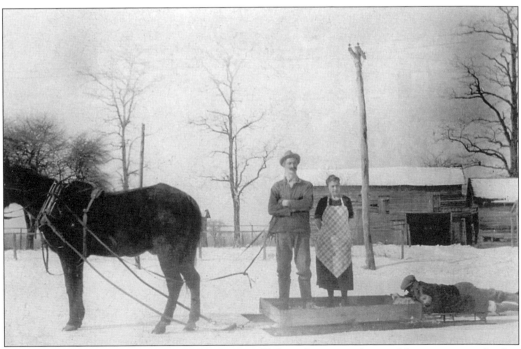

Not only were horses used for transportation and labor, they were also used for recreation. In this c. 1928 image, a family poses for a photograph as the two youngsters prepare for a horse-drawn sleigh ride. (Courtesy of Jackson Township Historic Commission.)

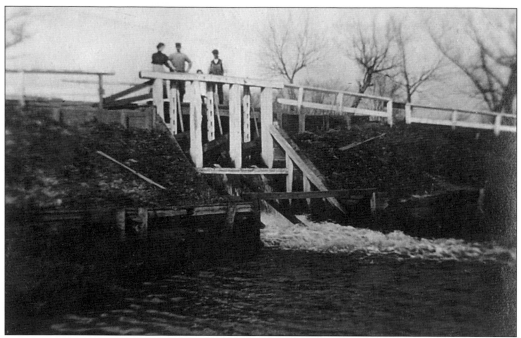

Jackson Township became synonymous with the cranberry industry in the late 19th century, and the fruit helped drive the local economy for the next 100 years. In this photograph from the early 1900s, cranberry farmers divert river water to flood a bog so that the plant is protected from winter. (Courtesy of Jackson Township Historic Commission.)

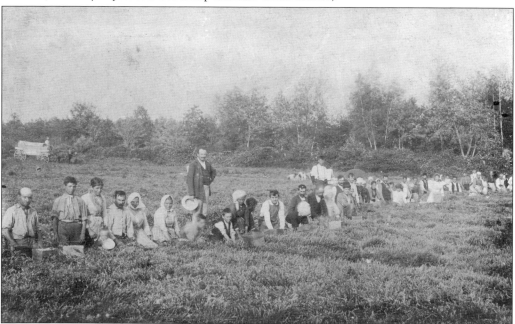

At one time, there were approximately 260 cranberry bogs in Jackson, and many area residents took advantage of the cranberry boom. Cranberries were harvested in October, and the township's one-room schoolhouses would close for part of the month so children could help pick cranberries from the vine. (Courtesy of Jackson Township Historic Commission.)

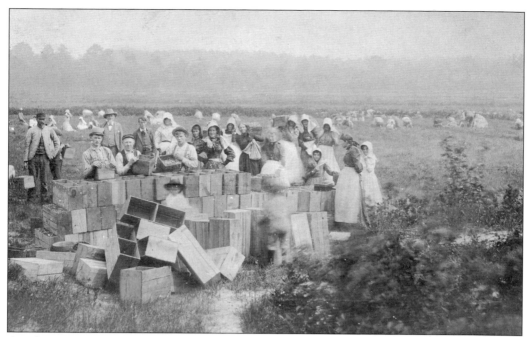

Cranberry picking was labor intensive, and for families who worked cranberry bogs, harvest time was a family affair. For younger children, small fingers served as perfect tools for picking berries and helping to collect them in buckets. Without help from these little laborers, the process would have been significantly longer and more tedious. (Courtesy of Jackson Township Historic Commission.)

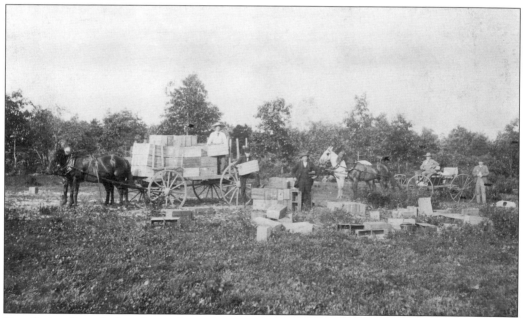

Benefitting from Jackson's cranberry boom, other area businesses began to capitalize on the high demand for the fruit. Local sawmills provided lumber for crates and barrels used to ship cranberries via railroad and ships, both nationally and abroad. (Courtesy of Jackson Township Historic Commission.)

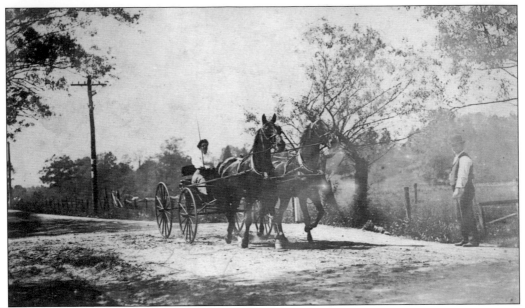

The local economy of the late 19th century was not much different than in previous generations. Farmers would grow crops for sustenance, then would barter or sell the surplus. Large surpluses would be loaded onto horse-drawn carriages and taken down one of several dirt roads. In this 1892 photograph, a carriage rambles down the road on its way to a local market. (Courtesy of the Holman family.)

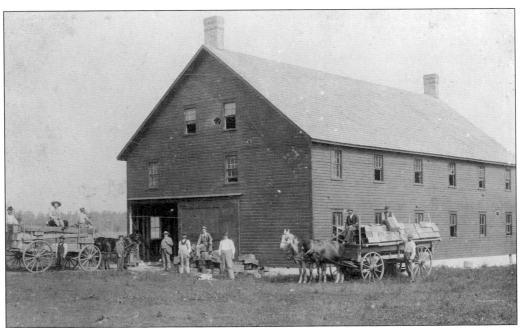

Once packed in crates, cranberries were shipped throughout the United States and overseas. In this photograph taken about 1900, crates of cranberries have been loaded on horse-drawn wagons headed for various destinations. (Courtesy of Jackson Township Historic Commission.)

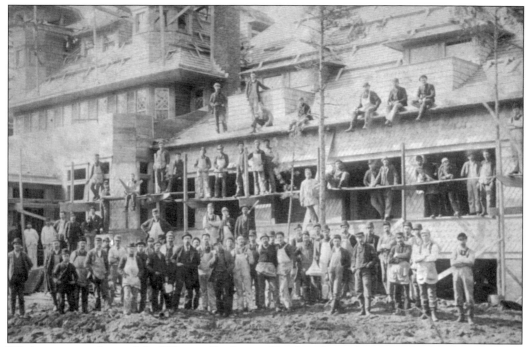

Workers pose in front of the Whitesville Casino Hotel in the early 1890s. The hotel, located off present-day Faraday Avenue, was designed to be a contemporary luxury resort complete with ornate ballrooms, state-of-the-art dining facilities, decadent private rooms, and numerous recreational facilities. Just prior to the hotel opening its doors, a fire destroyed the structure and the project was abandoned. (Courtesy of Jim Doyle.)

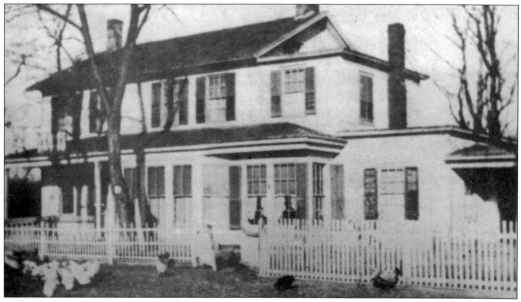

The Jamison General Store, pictured here around 1920, was located at the intersection of Bennett Mills Road and East Veterans Highway. The post office also operated from here until the 1950s. Twice a week a postal employee traveled to Jackson Township's South Lakewood train station to retrieve mail for area residents. (Courtesy of Jackson Township Historic Commission.)

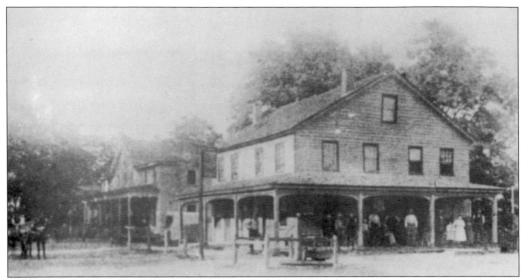

Many people gathered at the Cassville Hotel, now known as the Cassville Tavern. Located at the corner of present-day Route 571 and West Veterans Highway, it served as a stagecoach stop and inn for travelers at a time when local taverns served as the unofficial meeting place for many small towns. Located next to the tavern was Allen's General Store, where it is said the original boundaries of Jackson Township were drawn. The general store, now Art & Kathy's Kitchen, is still owned and operated by descendants of the Allen family. (Courtesy John Fariello.)

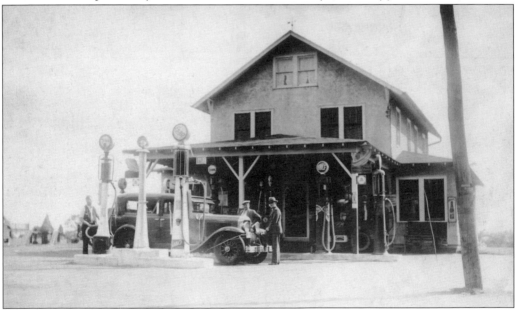

Many intersections in town were referred to by the property owner's name. Lambert's Corner, located at the modern intersection of East Veterans Highway and Hope Chapel Road, was owned by John and Minnie Lambert. The couple operated a filling station and lunch counter and lived on the second floor. Minnie cooked for customers while John ran the service station, which featured gravity-fed pumps. Gas cost 11¢ per gallon when this photograph was taken in 1932. The Lamberts sold their property to Willy Langbein, and the corner subsequently became known as Willy's Corner. (Courtesy of Steve and Eileen Lambert.)

In the late 1800s, the Jamison General Store was located in the Van Hiseville section of Jackson, near the modern-day intersection of Bennett Mill Road and East Veterans Highway. In addition to offering staple goods, the store doubled as the local post office, with mail delivered twice weekly via Jackson's South Lakewood train station. Before it was known as Van Hiseville, this section of Jackson was called Irish Mills. Howard Jamison was the original owner of the store. His nephew Wally and Wally's wife, Marge, still reside in town. (Courtesy of Jackson Township Historic Commission.)

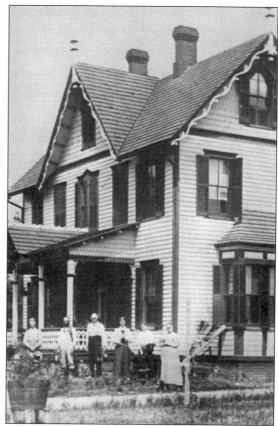

Local resident Ray Hendrickson is pictured at the Applegate General Store in 1955. One of many general stores scattered throughout town, the Applegate General Store was located in the Jackson Mills section. The general store provided a variety of goods and served as a central meeting place for township residents. The Applegate General Store remained open until 1969. (Courtesy of the Lorraine Applegate collection.)

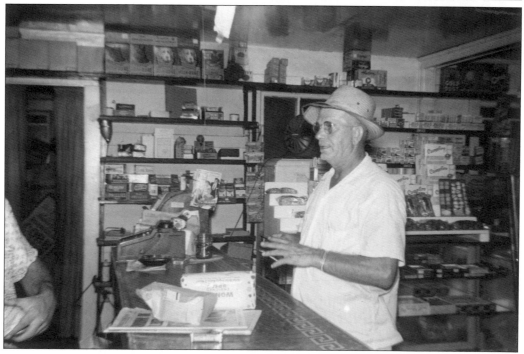

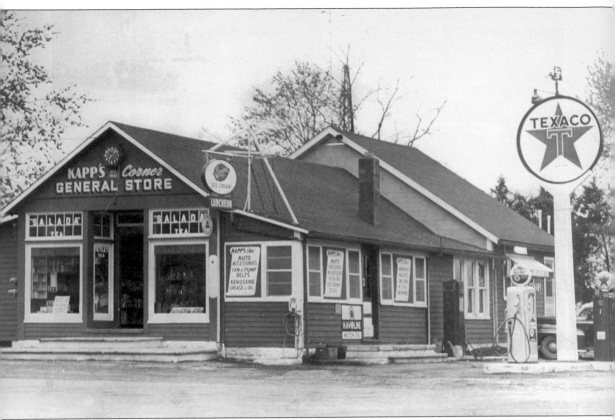

Kapp's General Store was located at the intersection of Whitesville and Hope Chapel Roads. This store started as a vegetable stand run by the Kapp family, who emigrated from Hungary in the 1920s. For decades, area residents would gather in the back room around a wood-burning stove and discuss the news of the day. When the *Hindenburg* exploded in 1937 in nearby Lakehurst, hundreds of reporters and investigators descended upon Kapp's Corner for food and information. (Courtesy of Lois Kapp.)

GLORY-BEST BRAND (REG.) CHICKENS

AND CHICKEN PRODUCTS
TRY ONE TODAY

1	SOUTHERN FRIED CHICKEN	PRICE	12	CHICKEN WINGS	PRICE

John Mislovski and his son Boris emigrated from Russia to the United States in the late 1930s to escape the political turmoil. John was so moved by the sentiment expressed by Americans singing the "Glory, Glory, Hallelujah" refrain of "Battle Hymn of the Republic," he decided to change his last name to Glory. John and his family established a chicken farm in Jackson for the purpose of raising broilers. Boris and his wife, Katherine, established a similar farm on the present-day site of Glory's Market. Glory's Market is now owned and operated by Boris and Katherine's sons Walter and George and their wives Denise and Clara. (Courtesy of the Glory family.)

In the first half of the 20th century, eggs surpassed cranberries as Jackson's most prominent agricultural product, and chicken coops were visible throughout the town. In this 1960s photograph, Edith Kornbluth poses in front of a chicken coop. William and Edith Kornbluth emigrated from Poland after surviving the Holocaust. William spent several years in four concentration camps. Edith survived the war by posing as a Catholic. William documented their wartime experience in a book entitled *Sentenced to Remember*. (Courtesy of Phil Kornbluth.)

23

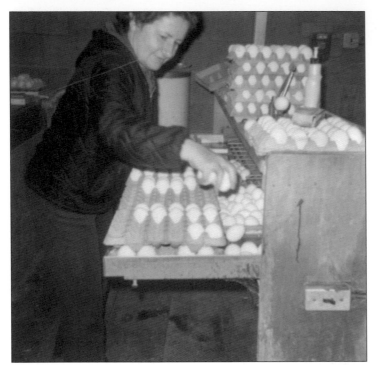

The final segment of the egg-harvesting process was sorting the eggs into cartons for eventual delivery, as shown by Edith Kornbluth in this 1970s photograph. The egg-harvesting business began to decline in Jackson after 1950 as the increasing cost of chicken feed made turning a profit a near impossible endeavor. When traveling through Jackson today, remnants of chicken coops still exist in some locations. (Courtesy of Phil Kornbluth.)

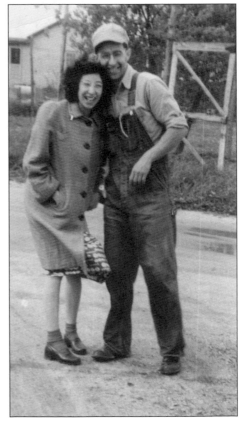

Manfred and Hilda Lindauer owned a chicken farm located off present-day Hope Chapel Road. In 1932, Hilda (Schein) arrived in Jackson. As youngsters, she and her brother Davy walked to the two-room Whitesville School. Manfred Lindauer had suffered at the hands of the Nazis and was placed into a concentration camp. After receiving sponsorship from an American uncle whom he had never met, Lindauer emigrated from Germany to the United States. While in Germany, Manfred attended a school that taught young Jewish men to farm. Lindauer first worked on a Virginia farm building chicken coops for three years, then moved to Jackson to work in the poultry industry. Schein sent his daughter Hilda to pick up Manfred, and she was smitten at first sight. Manfred and Hilda Lindauer are shown here at their family chicken farm, where they raised their four children. (Courtesy of Hilda Lindauer.)

The Lindauer family raised thousands of chickens and delivered eggs throughout the Northeast. They also sold eggs to local residents and merchants. Pictured here is a brooder house, where baby chicks were kept warm until they were old enough to survive without the additional heat. (Courtesy of Hilda Lindauer.)

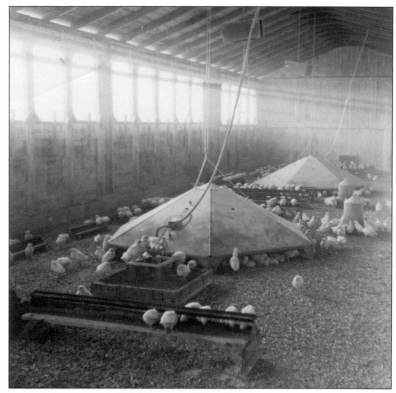

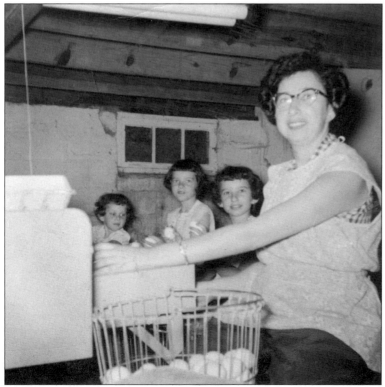

Hilda Lindauer is pictured here grading eggs with her three daughters. Eggs were graded on the basis of their size and quality. The family eventually sold the farm, and Hilda became a teacher and school librarian at Switlik Elementary School. (Courtesy of Hilda Lindauer.)

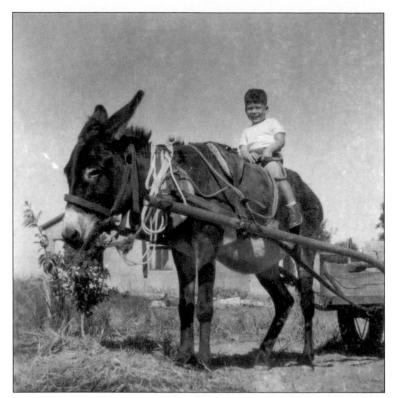

Saul Lindauer is pictured here on the family mule, which was utilized often on the farm. After years of farming, the Lindauers sold off all but two acres of their property and used the profit to pay for their children's educations. (Courtesy of Hilda Lindauer.)

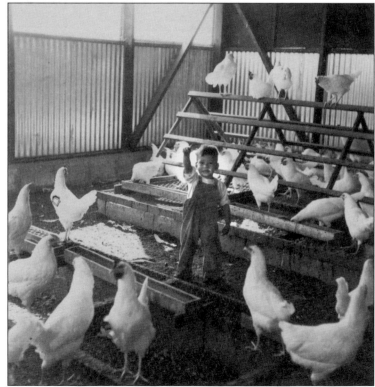

Chicken coops were part of the landscape in Jackson for many years. A young Saul Lindauer is pictured here inside one of the family's many chicken coops. (Courtesy of Hilda Lindauer.)

By the 1930s, chicken and egg farms were commonplace throughout Jackson, to the extent that it is believed that chickens outnumbered people in town. Egg farming was a relatively easy and inexpensive business to start. Many people came to Jackson to enter the poultry industry. This photograph is of a typical chicken farm from the 1940s. (Courtesy of Hilda Lindauer.)

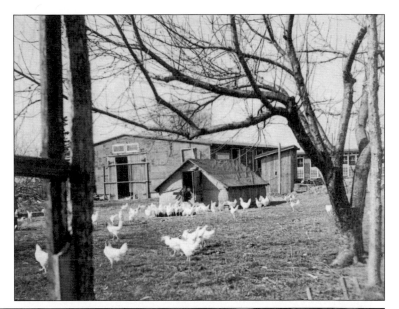

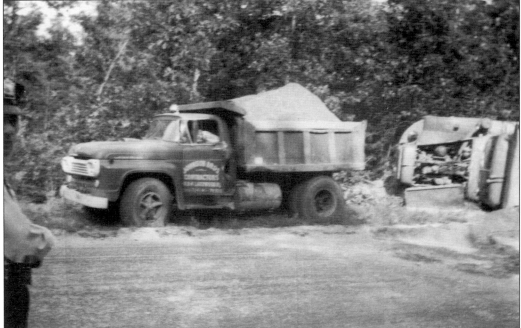

In 1948, James Johnson started a trucking business and most of his business came from the cleaning of chicken coops in Jackson. That same year, he was hired to transport gravel used to construct the New Jersey Turnpike. His brother William joined him in 1950 and the company name became Johnson Brothers Trucking. In 1965, the brothers incorporated under the name Bil-Jim Construction Co. and expanded their business to include site clearing and other general construction functions. Today, Bil-Jim Construction continues operations under the ownership of James's children and grandchildren. Pictured here is one of the company's first trucks, identified by the Johnson Brothers Trucking logo on the door. At the height of the construction boom in the early 2000s, the company had a fleet of 257 trucks and heavy equipment machinery as well as 165 employees. (Courtesy of Laura Johnson.)

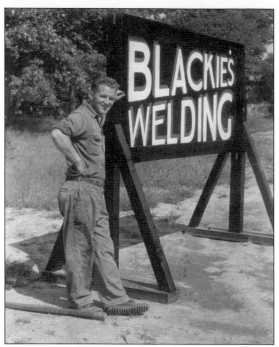

Lloyd Black was born in Manhattan and moved to Jackson in 1927. He attended the Cassville School and later served in the US Navy during World War II. Black raised his family in Jackson and opened Blackie's Welding Service in 1960. The business specialized in serving farmers, contractors, and homeowners and was involved extensively in the mining industry, which thrived in Jackson in the 1960s and 1970s. Black proudly supported local civic organizations and the education system. This Jackson landmark is still operated by his family today. (Courtesy of Daniel J. Black.)

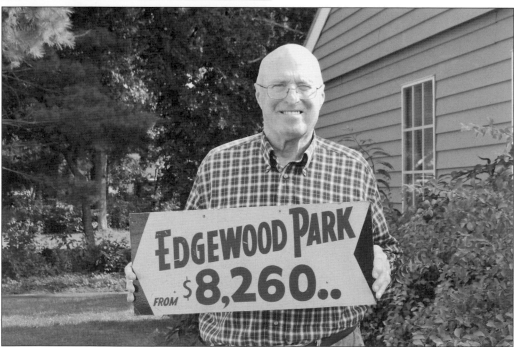

The population in Jackson Township expanded in the 1960s. Many people began to escape city life for a quieter existence in the countryside. Jackson became a magnet, attracting thousands of people wishing to purchase homes. With low interest rates for first-time home buyers and veterans, Jackson's real estate market was thriving. Signs by Schaf, owned by brothers William and Joseph Schaf, painted many of real estate signs advertising low-cost houses. In the early 1960s, homes in the Edgewood section of town could be purchased for $8,260! (Photograph by Victoria O'Donnell.)

Two

SCHOOLS

The Prospertown Schoolhouse was built in the mid-1800s and was utilized as an educational facility until 1923. Early schoolhouses included Cassville, Cranbury, Holmansville, Jackson Mills, Leesville, Midwood (Davisville), New Prospect (Hyson), Pleasant Grove, Prospertown, Webbsville, and Whitesville. Shown here in its original Prospertown location, its remnants can still be found today off Route 537 near the Prospertown Lake. (Courtesy of Jackson Township Historic Commission.)

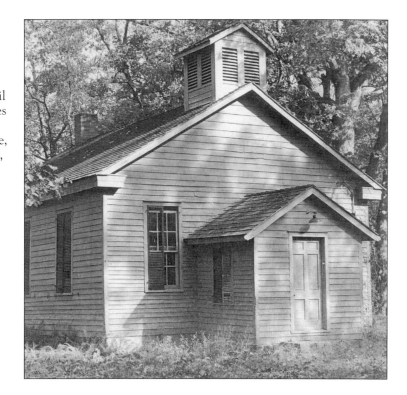

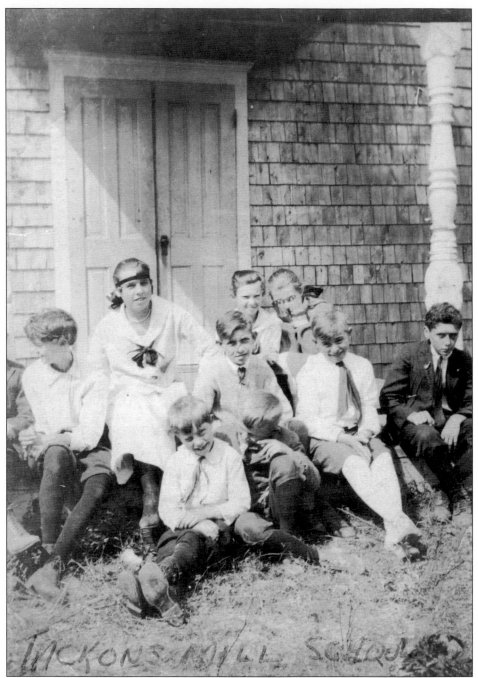

Children gather in front of the Jackson Mills School. The Jackson Mills School operated from 1845 to 1930. It was located on Route 526 near Jackson Mills Freehold Road. Although the students are not identified in this c. 1925 photograph, it is noticeable that there were a variety of ages, and children were seated in rows according to their grade level. The teacher would instruct students by row while others worked independently. In addition to classroom instruction, teachers had a variety of duties, such as preparing the wood-burning stove, cleaning the school, and at times preparing breakfast for the students. (Courtesy of Jackson Township Historic Commission.)

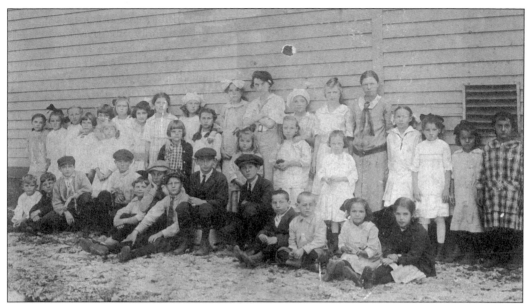

Each of Jackson's 11 one-room schoolhouses accommodated up to 40 students, although many students would help their families on the farm and regularly miss school. All 11 schools had similar features. The county's Department of Education recommended one-acre school sites, large windows, and wood-burning stoves for heat. Each classroom had a chalkboard, an area to display student work, a bell, and portraits of Presidents Washington and Lincoln. This c. 1915 image shows a typical group of Jackson students. (Courtesy of Jackson Township Historic Commission.)

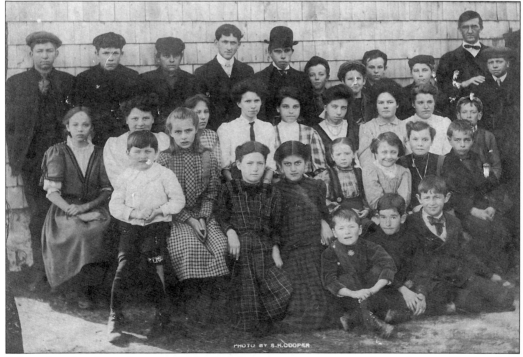

Believed to date from the early 1900s, this class portrait was captured outside one of Jackson's 11 one-room schoolhouses. (Courtesy of Jackson Township Historic Commission.)

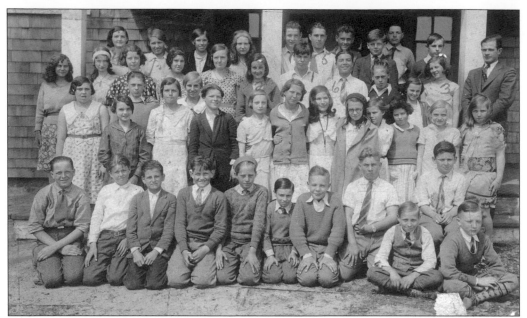

In this photograph taken in the 1930s, Jackson Mills School students pose for a school portrait. Lindsey Leming, who served as the primary teacher in the one-room schoolhouse, wears a suit on the far right. (Courtesy of the Lorraine Applegate collection.)

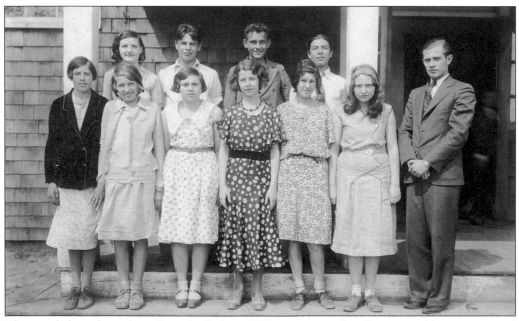

These eighth grade students from the Jackson Mills one-room schoolhouse would go on to attend nearby Lakewood High School. Jackson Township did not have its own high school until 1963; it was called Jackson Junior-Senior High School, now known as Jackson Memorial High School. The community added a second high school, Jackson Liberty High School, in 2006. The teacher pictured here on the far right is Lindsey Leming. (Courtesy of the Lorraine Applegate collection.)

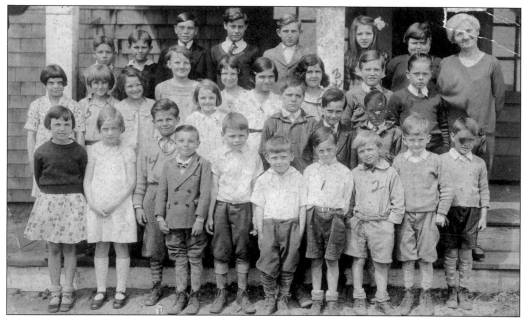

A group of mostly young students pose for a class portrait outside the Jackson Mills School in the 1930s. (Courtesy of the Lorraine Applegate collection.)

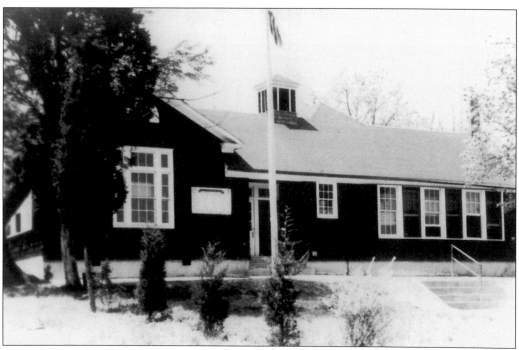

Cassville School is shown here as a three-room schoolhouse. It was established in the first half of the 19th century and operated as a one-room schoolhouse for many years. As Cassville grew, two more classrooms were added, and the school remained in use into the 1960s. (Courtesy of Daniel J. Black.)

Two students pose in the 1950s for a picture in one of three classrooms at the Cassville School. Many schoolhouses looked similar inside with wood desks, an American flag, and photographs of American icons, such as George Washington and Abraham Lincoln. (Courtesy of Jackson School District.)

In this 1950 photograph, children work on reading exercises inside the Cassville School. Reading, writing, and arithmetic were heavily emphasized in the curriculum of the day, although as evidenced in this photograph, some worked harder than others. (Courtesy of Jackson School District)

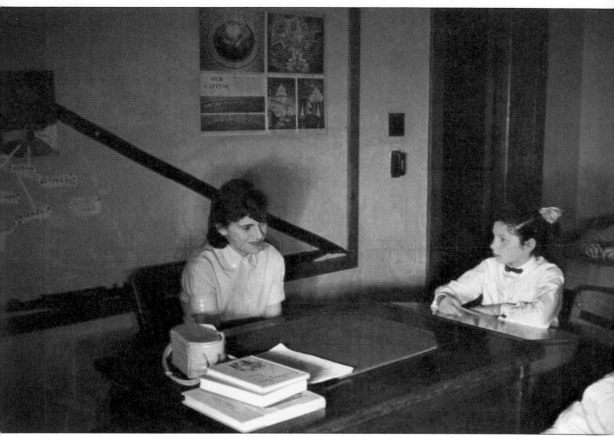

The Cassville School's three-room schoolhouse had different teachers for each of the rooms. In this photograph, taken in the mid-1950s, a teacher poses with a student. (Courtesy of Jackson School District.)

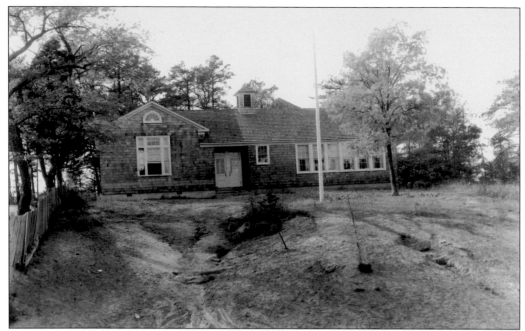

In this mid-20th century photograph, the Cassville schoolhouse had been expanded into three rooms. The new addition, which juts out to the right, is easily differentiated from the old portion. Several generations of Cassville residents learned in this building, which served the community for more than a century. (Courtesy of Daniel J. Black)

The Pleasant Grove School was located adjacent to the Pleasant Grove Methodist Church. The building was constructed in 1865 and was previously utilized as a central meetinghouse for local Grange members. At the Grange Hall, farmers would discuss ways to collectively fight against economic abuse in the agriculture industry by monopolies, such as the railroad companies. (Courtesy of Jackson Township Historic Commission.)

The Prospertown schoolhouse was moved to its present location in the 1980s and was converted into a township museum. Located under the left window is the original bell that rang each morning to signal the start of class. (Courtesy of Jackson Township Historic Commission.)

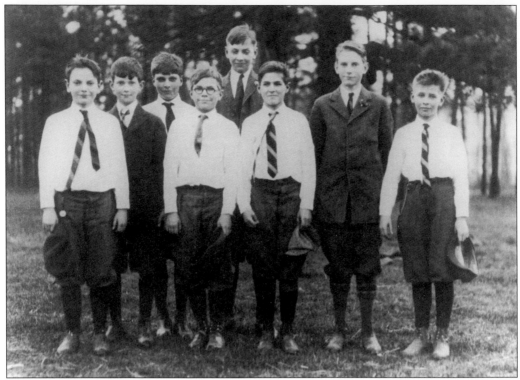

In 1904, Frank L. Olmsted opened the Pine Lodge School, which was located on present-day East Veterans Highway. Olmsted, a Harvard graduate, operated the school for over a decade, educating up to 10 students per year. This photograph was taken in front of the Olmsted mansion with the Pine Lodge class of 1918–1919. As identified by Laurance Rockefeller, from left to right are Laurance Rockefeller, ? Douglas, ? Rauds, ? White, Joe Roebling, Kenneth Jenkins, John Rockefeller III, and Peter Goelet. (Courtesy of the Rockefeller Archive Center.)

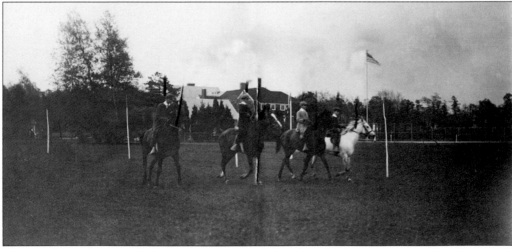

The Gymkhana consisted of a series of events, including horseback competitions. This photograph was taken in the field adjacent to the Pine Lodge School. Laurance Rockefeller identifies the competitors as well as their horses. From left to right are Joe and Punch, Steven and Andy, Ken and Mira, and Laurence and Nancy. (Courtesy of the Rockefeller Archive Center.)

Jackson Township's first central elementary school opened in 1948. The school, named for local parachute pioneer Stanley Switlik, was a state-of-the-art facility that marked the beginning of the end for Jackson's one-room schoolhouses. (Courtesy of Jackson Township School District.)

Esther Van Hise (left) of Switlik Elementary School began her career in several one-room schoolhouses around Jackson. In this photograph, Esther Van Hise is pictured with Stanley Switlik and an unidentified woman. (Courtesy of Jackson Township School District.)

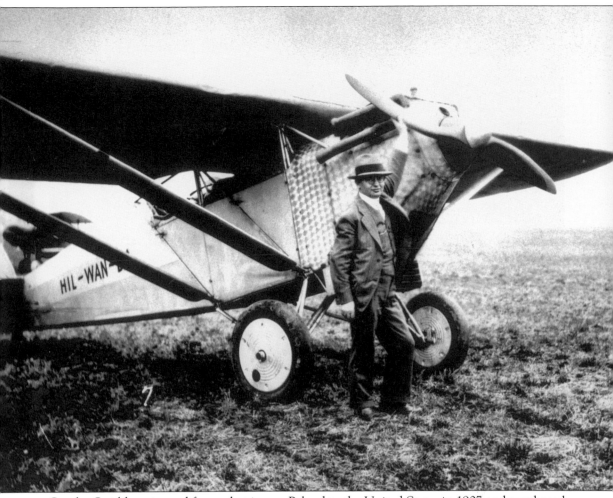

Stanley Switlik emigrated from what is now Poland to the United States in 1907 and purchased a canvas manufacturing business in 1920. By 1930, Switlik began experimenting with parachutes and eventually drew the interest of George Palmer Putnam and his famous wife, Amelia Earhart. In 1935, Switlik and Putnam built the first-ever parachute test tower in Jackson Township, and Earhart even made the first public jump from the 115-foot structure. Soon after, Switlik's company became a major supplier of parachutes to the US government, and thousands of pilots were saved by Switlik's models throughout World War II. Former president George H.W. Bush has often described how his Switlik parachute saved his life when his Navy fighter was shot down over the Pacific in 1944. Dedicating much of his fortune to philanthropy, Switlik donated the land and building materials for the first traditional school in town. In honor of Switlik's charity as well as his reputation as an innovator and aviation pioneer, the Switlik Elementary School was dedicated in Jackson in 1948. (Courtesy of Jackson Township School District.)

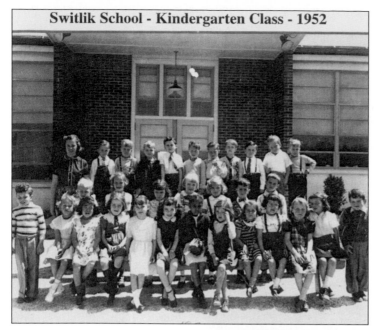

Switlik School - Kindergarten Class - 1952

The 1952 kindergarten class from Switlik Elementary School is shown here. Some of these students were among the first to attend Jackson Junior-Senior High School, which was established in 1963. (Courtesy of Jackson Township School District.)

Esther Van Hise, a well-respected teacher in the Jackson School District, is shown here during recess at the Switlik Elementary School, where she taught fourth grade. Van Hise was born in Cassville, the daughter of a Civil War veteran. As a student, she attended a one-room schoolhouse in Cassville. Inspired by her teacher W. Clement Moore, she became a teacher. During her tenure in the Jackson School District, Van Hise taught at the one-room schoolhouses in Webbsville, Holmansville, and Cassville. Van Hise walked a mile and a half each day to the school in Cassville. Later, she moved to Jackson's first modern school, Switlik Elementary School, where she retired after educating the students of Jackson for 46 years. (Courtesy of Jackson Township School District.)

Baseball was high on the list of popular recess activities at Switlik Elementary School. Unlike today when baseball players rely on high-tech, specialized equipment, children of the 1950s only needed a baseball, a bat, and an open space to start a game and pretend to be contemporary heroes, such as Mickey Mantle and Willie Mays. (Courtesy of Jackson Township School District.)

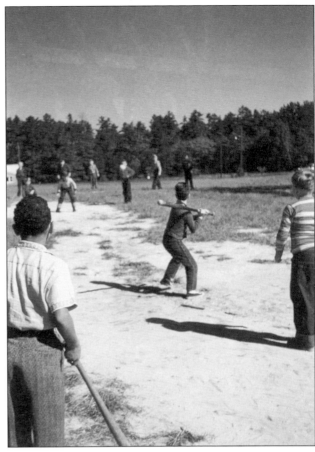

Children of today might not recognize crates and barrels as potential playground equipment, but in the 1950s kids used whatever they could to have fun. The crates and barrels in the photograph were likely produced at a local sawmill and donated to Switlik Elementary School. (Courtesy of Jackson Township School District.)

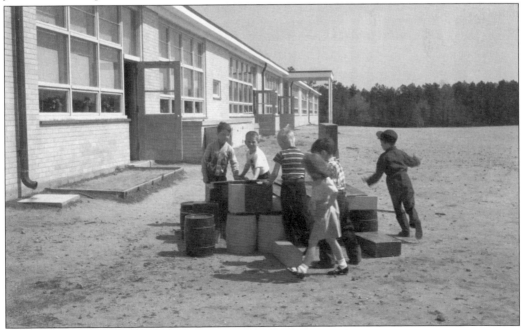

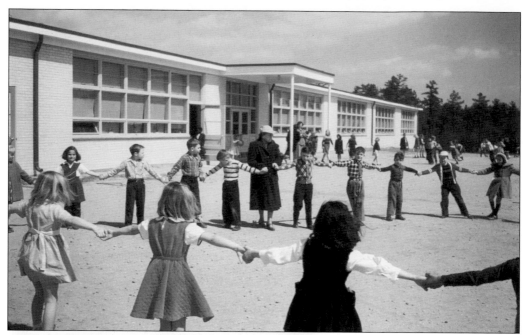

Students are shown dancing during their recess at the Switlik Elementary School. Dancing was one of many activities in which children took part. (Courtesy of Jackson Township School District.)

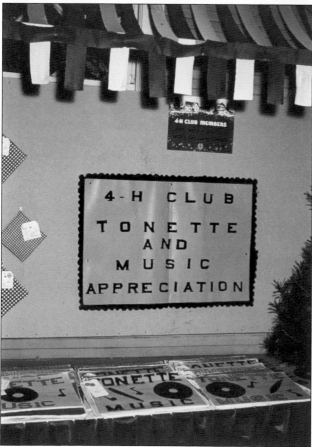

In the 1950s and 1960s, 4-H Club programs offered more than just agricultural education to rural communities. This event focused on the arts and offered a rock 'n' roll music appreciation for Switlik Elementary School. (Courtesy of Jackson Township School District.)

With agriculture comprising a significant share of the local economy, 4-H Club activities were prevalent throughout school curriculum. In this photograph, students are being given an outdoor lesson on planting. (Courtesy of Jackson Township School District.)

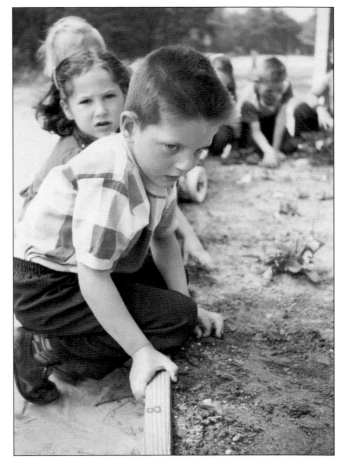

The May Day Festival was not complete without an official maypole. Children at Switlik Elementary School gathered to dance around the maypole, winding ribbons around it. (Courtesy of Jackson Township School District.)

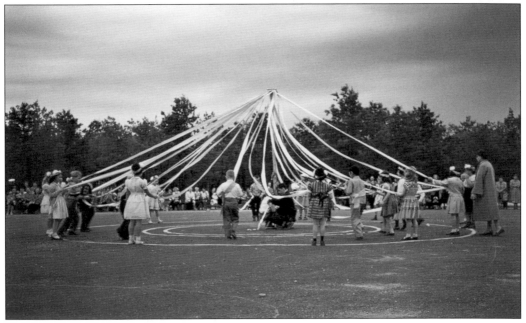

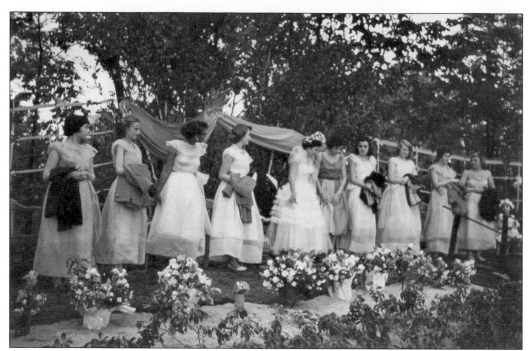

Like much of America, Jackson children and adults celebrated May Day throughout the 1950s, complete with dancing, singing, and fun activities. Shown here is the 1951 ceremony to crown the May Day queen. (Courtesy of Jackson Township School District.)

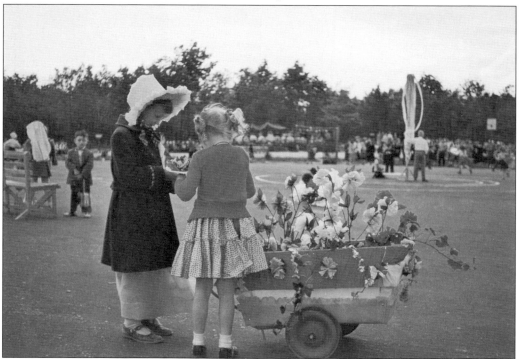

April showers bring May flowers! A beautiful bouquet is wheeled into the May Day celebration. (Courtesy of Jackson Township School District.)

John F. Johnson, a Switlik student, was a lifelong Jackson resident. He was elected governor of the New Jersey District of Key Clubs as a student at Jackson Memorial High School, a position no other Jackson student has held since. Johnson became the town's business administrator and was involved in many community activities. Johnson drowned while attempting to save the life of a stranger during a trip to Island Beach State Park. In 1979, he was posthumously awarded and recognized for his valor and extraordinary courage by Mayor Arleen Polito. In 1980, Johnson Park, located on Cooks Bridge Road, was named in his honor. Interestingly, John had written a successful grant application to help secure this site as open space for the recreational needs of Jackson citizens. (Courtesy of the Johnson family.)

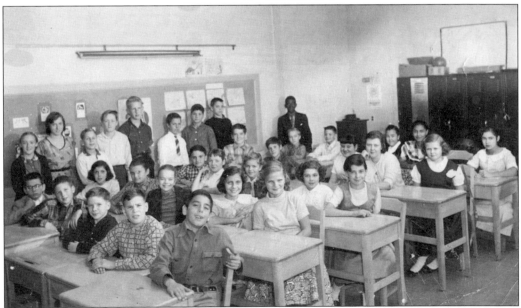

This 1957 photograph features students from Switlik Elementary School. Some of the students pictured are Mark Wonderman, Richard Parnelll, Robert Wolf, and Ronnie Rivera, Lillie Sachs, Karen Winchester, Penny Peterson, Mike Costa, Ruth McLaughlin, Marie Ercolino, Madelyn Thompson, Russell Archer, Daisy Ipock, Lorraine Lamanski, Gloria Fernandez, Angelica Lamos, Rachel Little, Barbara Vargo, Eddie Stevenson, Ralph Rogove, Jimmy Infuna, Richard Lanko, and Sam Hanna. (Courtesy of Gloria Yanis.)

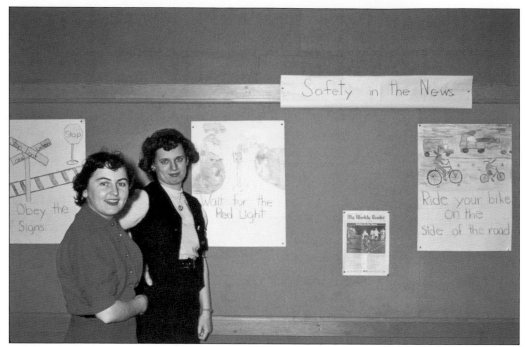

Teachers at the Cassville three-room schoolhouse pose next to a student display of safe bicycle and driving practices. The theme was "Safety in the News," a topic taken from *My Weekly Reader* c. 1953. (Courtesy of Jackson School District.)

By the 1950s, chicken coops were appearing in Jackson with regularity and egg farming became a Jackson niche. At the Ocean County Fair, Jackson citizens competed in numerous "best chicken" competitions. (Courtesy of Jackson School District.)

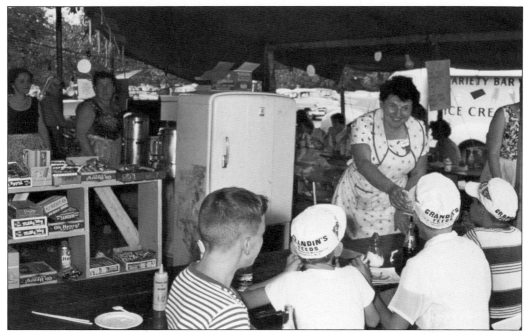

At the Ocean County Fair in the 1950s, kids sidle up to the counter for candy, soda, and ice cream. Hamburgers and hot dogs sold for 25¢. (Courtesy of Jackson Township School District.)

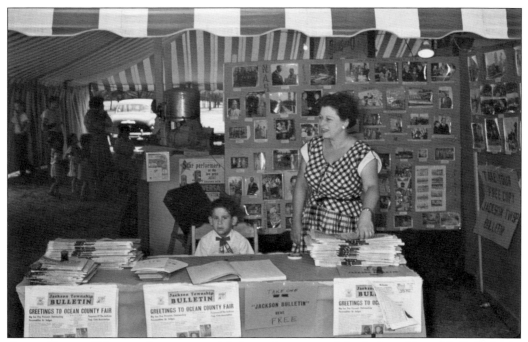

Ocean County Fair attendees were entitled to a free copy of the *Jackson Township Bulletin*. In this 1950s photograph, Jackson resident Ida Ebert and her son Jason oversee distribution of the freebies. The *Bulletin*'s headline offered greetings to Ocean County fairgoers. (Courtesy of Jackson Township School District.)

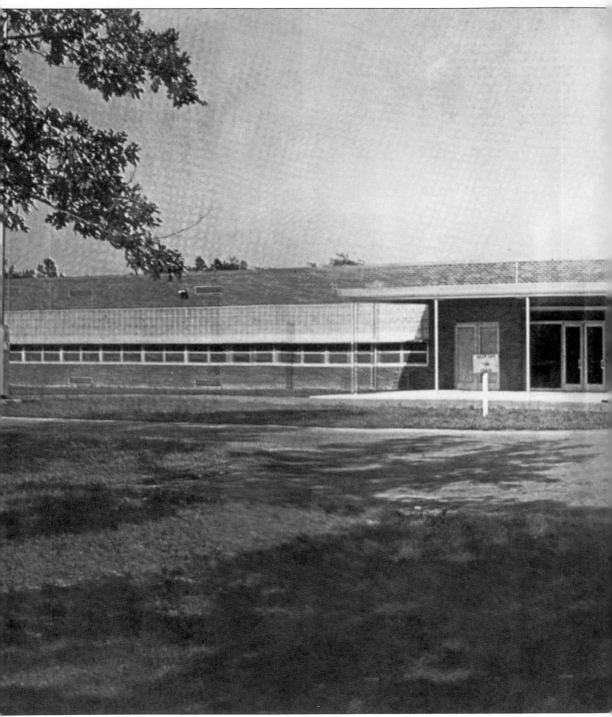

After traveling to nearby Lakewood for years, students from Jackson walked into a new high school in 1964. The school was named Jackson Junior-Senior High School and was built with one floor. Today, known as Jackson Memorial High School, a second floor has been added. The Joseph E. Clayton Building was also constructed adjacent to the original school. Dr. Clayton

attended the one-room schoolhouse in Jackson Mills. He enjoyed a long career in education as a teacher and principal and in several positions for the Department of Education. (Courtesy of Jackson Township School District.)

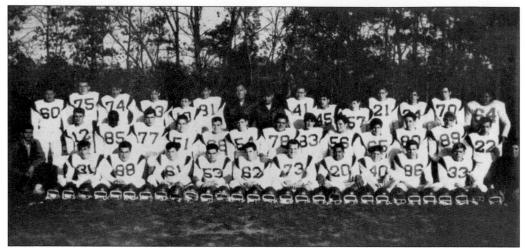

A new high school meant new traditions. Following its opening in 1964, Jackson Memorial High School began to compete in athletics. The first graduating class chose the jaguar as the school mascot and black and red as the school colors. Pictured here is the 1966 Jackson Jaguars football team with head coach John "Jack" Munley and assistant coach John Amabile. The football field is named Munley Field in honor of the first football coach. (Courtesy of Jackson School District.)

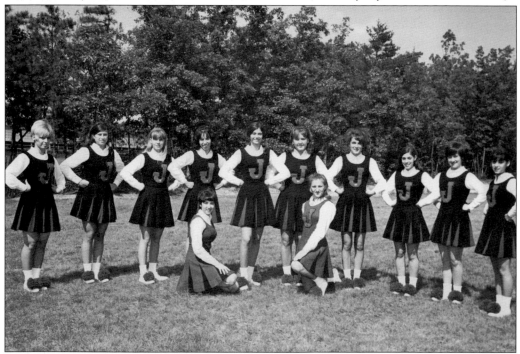

The Jackson community quickly warmed up to the idea of having its own high school, and athletic programs were a big part of the excitement. Fans were eager to support the teams and were encouraged to do so by the efforts of the first Jackson cheerleading team. Pictured here on an early cheerleading squad are, from left to right, (kneeling) Rose Amanik and Lina Pollie; (standing) Doris Niziolek, Christina Adams, Charlotte Klix, Debbie Lindauer, Cathy Kraft, MaryAnn Enkoff, Barbara Cull, Ronnie Liebowitz, Ina Jo Donovan, and Cindy Seidman. (Courtesy of Jackson School District.)

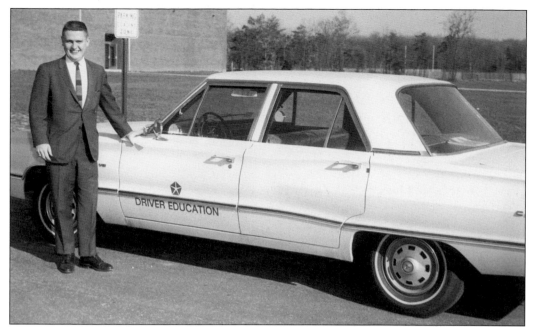

Donald F. Connor was one of the most respected athletic directors in the history of the Shore Conference during his tenure at Jackson Memorial High School. He also served the district as a teacher and a coach. He was the athletic director from 1961 until his untimely death in 1987. For two decades, he also served as Jackson Township's recreation director. In his honor, Jackson Township renamed the street where the high school and administration building are located to Don Connor Boulevard. In this c. 1970 image, Connor shows off the school district's driver's education automobile. (Courtesy of Jackson School District.)

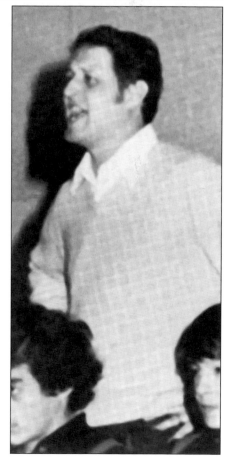

Bernard "Bernie" Reider was a Jackson Memorial High School fixture for 40 years, serving as math teacher, guidance counselor, coach, athletic director, vice principal, and principal from 1963 until 2003. He has remained an inspiration to his colleagues and students. His passion for education and athletics was unsurpassed. As wrestling coach, Reider began a great tradition at Jackson Memorial High School—guiding the team to multiple district championships and conference titles. When he retired, the school's Memorial Building was dedicated Bernie Reider Hall in his honor. Since then, Reider has dedicated much of his time to uncovering township history and historic preservation. Shown here in the mid-1970s, Reider coaches a wrestling competition, as former wrestlers Joe Rivera (left) and Lou Durant observe. (Courtesy of Jackson School District.)

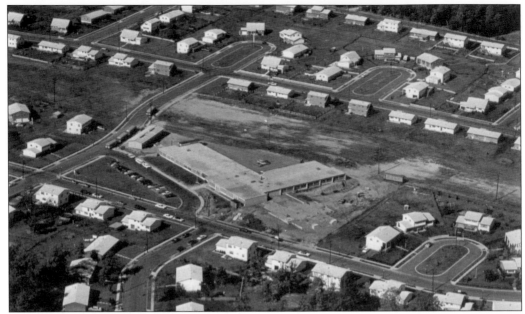

This 1962 aerial shot shows the Brookwood School, which had just been completed. It was renamed the Sylvia Rosenauer Elementary School in 1978, in honor of its first principal. (Courtesy of Jackson Township School District.)

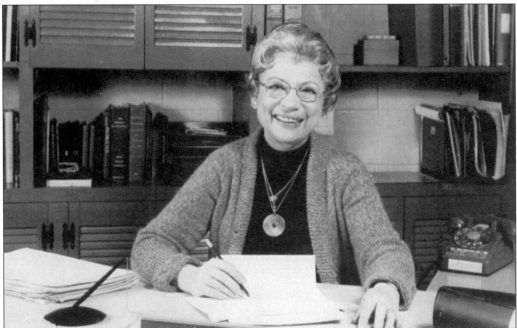

The Rosenauer School is named in honor of longtime Jackson educator Sylvia Rosenauer. After she graduated from Hunter College and received her master's degree from Rutgers University, Rosenauer began her teaching career in Lakehurst. In the late 1950s, she began teaching at Switlik Elementary School and was appointed inaugural principal of the new Brookwood School in 1962. At her retirement dinner in 1978, it was announced that the school would be renamed the Sylvia Rosenauer Elementary School. (Courtesy of Jackson Township School District.)

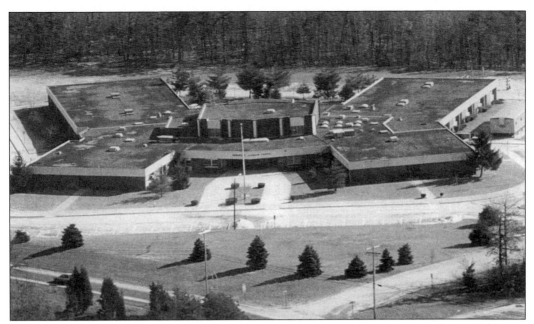

Named for the first Jackson resident to receive a high school diploma, the H.C. Johnson Elementary School opened its doors in 1969. Howard C. Johnson graduated from Lakewood High School in 1901. (Courtesy of Jackson Township School District.)

Howard C. Johnson was born in the Van Hiseville section of Jackson in 1882. After he completed the eighth grade in Jackson, he traveled each day to Lakewood High School to continue his education. The journey was 10 miles, which Johnson made by bike or by foot twice a day from his Bennett Mills Road home. Johnson was one of four students in the class of 1901 and was class president. He began his career as a teacher and eventually became supervising principal of the 10 district schools. Johnson and his wife are shown here at the Pine Lodge Estate, a private boarding school owned by Frank Olmsted. Johnson was dedicated to education and worked to gain support for a central school in town. In 1967, he returned to the classroom at the age of 85, where he gave his final lesson on the history of Jackson at the Switlik Elementary School. His legacy continues through his writings on Jackson history. (Courtesy of Verna Sprinkle.)

Lucy Holman, Switlik Elementary School principal, graduated from Lakewood High School in 1919, nearly a half century before Jackson would have its own high school. She attended the Normal School in Union City, where she earned a teaching certificate in 1921. In 1939, five Jackson Township Board of Education members showed up on her doorstep to ask if she would teach in a one-room schoolhouse that had lost its teacher. She agreed to teach, without pay, until a replacement was found, embarking on a 30-year career in Jackson. The district would eventually name an elementary school in her honor. (Courtesy of Jackson Township School District.)

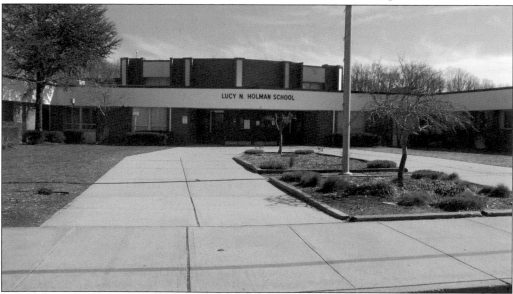

The Lucy N. Holman School opened its doors in 1969 on Manhattan Street. The school was named in honor of the dedicated Jackson educator. (Photograph by Victoria O'Donnell.)

Three

CHURCHES

A sign documents 100 years of the Cassville community. Originally called Goshen, a biblical reference meaning "land of plenty," the area was also named Downsville after a local family. In 1844, Downsville was renamed Cassville as a tribute to Lewis Cass, secretary of war under Andrew Jackson between 1831 and 1836. Cass was eventually elected to the US Senate from Michigan and also served as secretary of state under James Buchanan. (Courtesy of Verna Sprinkle from the Howard C. Johnson collection.)

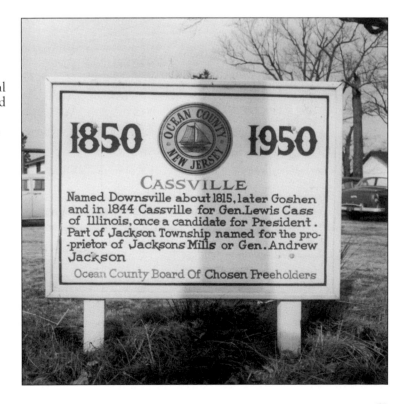

57

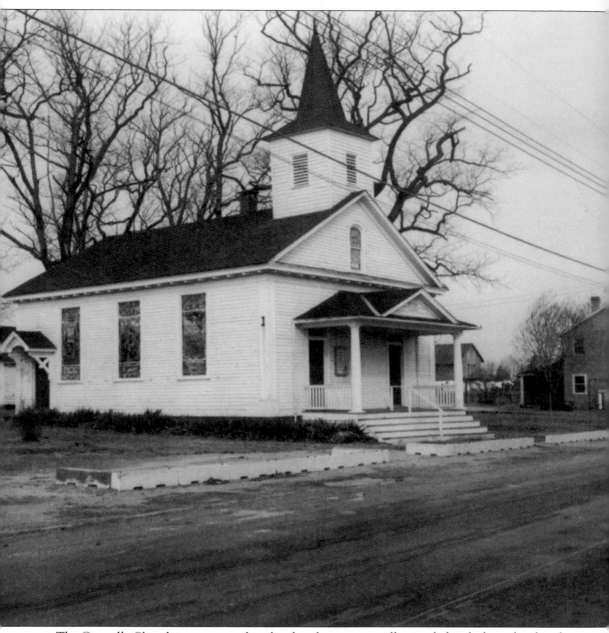

The Cassville Church is now gone, but the church cemetery still exists behind where the church once stood. Revolutionary soldier John Truex is among those interred at the cemetery. (Courtesy of Jackson Township Historic Commission.)

The Holmansville Church was originally constructed in 1849 as a house of Mormon worship, as evidenced by the Mormon cemetery still located behind the building. Presbyterians eventually took over the building, adding the steeple. In 1970, a retired New York minister, Reverend Kiel, rented the building from the Presbytery for $1 annually and renamed it the Jackson Community Bible Church. In 1990, the church was renamed the Faith Bible Church and today has 25 parishioners. (Courtesy of Jackson Township Historic Commission.)

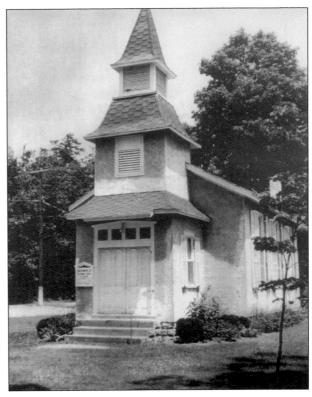

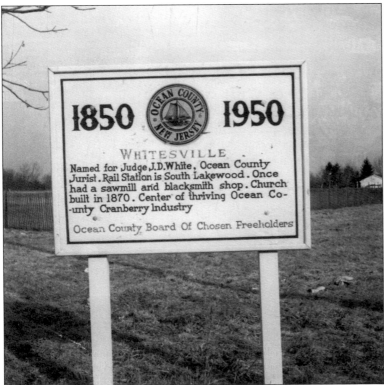

This 1950 sign commemorates the centennial of the thriving community of Whitesville, named in honor of Judge J.D. White. Whitesville was typical of small villages of the day, boasting an operating sawmill, church, and a schoolhouse. Whitesville also served the area as a transportation hub, as the South Lakewood railroad station was located in this area of town. (Courtesy of Verna Sprinkle from the Howard C. Johnson collection.)

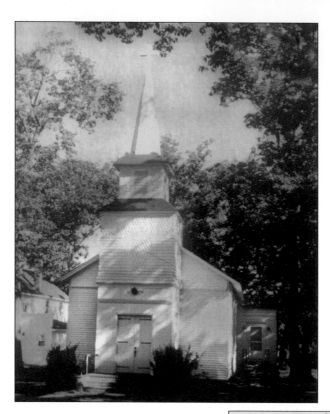

Built in 1870, Whitesville Church's property was donated by Judge J.D. White. The Whitesville Circuit also included Cassville and Pleasant Grove. In the late 1800s, the church was moved back from the road, and in the early 1900s, a social hall was built for parishioners. (Courtesy of Jackson Township Historic Commission.)

After meeting on the nearby farm of the Matthews family, the congregation built the first Harmony Church. It was built on land donated by John Ely Clayton and Silas Newman. The original building burned down in the mid-1800s and was replaced by the structure seen today, although it has not been actively used since 1989 and is in need of renovation. (Courtesy of Jackson Township Historic Commission.)

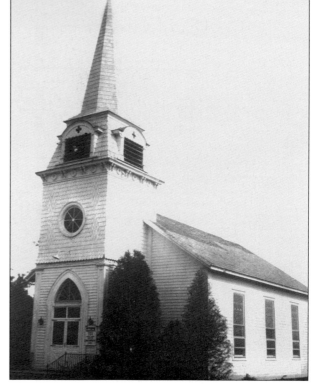

Pleasant Grove's congregation traces its origins to the early 19th century as a prayer group that met in the home of a member of the Holman family. The church gained its first full-time minister in the mid- to late 1800s The church is still utilized as a house of worship today. (Courtesy of Jackson Township Historic Commission.)

The DeBows Methodist Church began as the Methodist-Episcopal Sabbath School c. 1867. The land was originally owned by James DeBow and Thomas DeBow, and lumber for the church was provided by Joseph DeBow's nearby sawmill. In 1896, the building became a formal church under the leadership of minister Francis Fielder. Records show that in 1923 a belfry was constructed and a bell was purchased from the Sears and Roebuck catalog. In 1926, the church acquired a one-room schoolhouse from Millstone Township, which was used for social fellowship, harvest home dinners, and Sunday school. In 1953, the building was moved to accommodate a road-widening project, and the church hall was lost to a fire in 1963. (Courtesy of Bill Weitzen.)

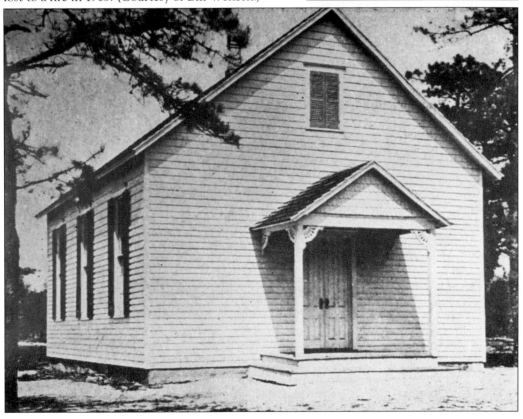

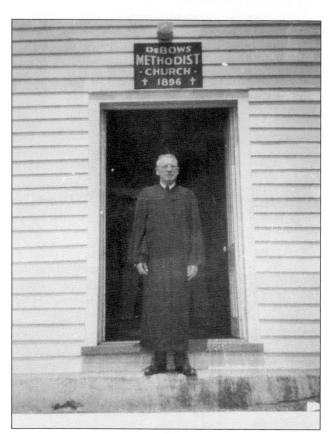

Francis Fielder was the first minister of the DeBows Methodist Church after it became a formal congregation in 1896. Under Fielder's leadership, the congregation grew and physical improvements to the church were made. (Courtesy of Bill Weitzen.)

The Dew Drop Diner was located across the street from the DeBows Methodist Church. This corner was known as Holmeson's corner, after Anne Holmeson, who owned the diner. The diner was especially busy on days when the church congregation was present. (Courtesy of Bill Weitzen.)

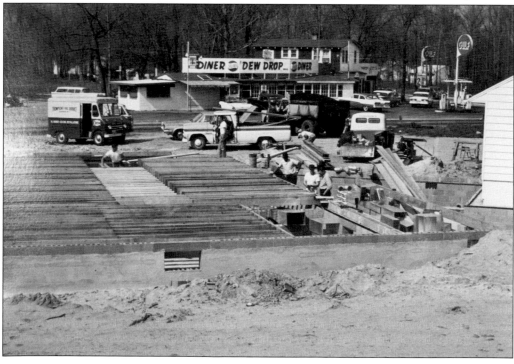

In 1965, contractors removed the bell from the DeBows Methodist Church. In this photograph, site construction supervisors are managing the removal, delicately helping the bell's descent from the belfry to the ground. (Courtesy of Bill Weitzen.)

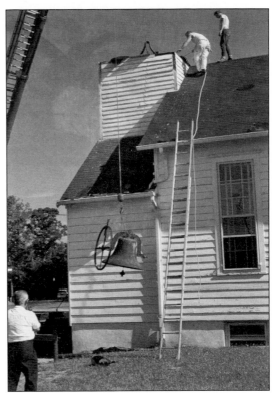

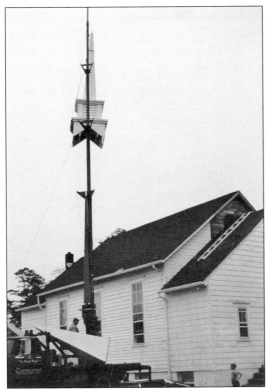

As the steeple of the DeBows Methodist Church was being installed by a crane in 1965, a young boy was among the curious passersby. (Courtesy of Bill Weitzen.)

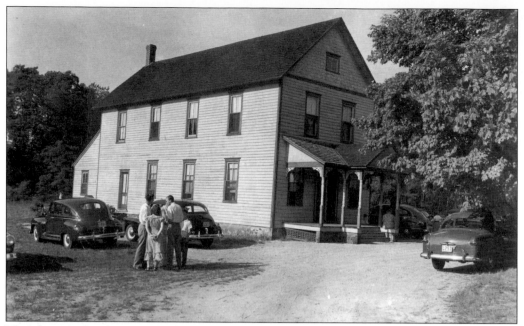

This photograph, taken in 1950, shows area residents gathering for Home Day at Harmony Hall. Home Day was a long-standing tradition much like a high school homecoming, as natives of Jackson were called back home to the annual reunion. (Courtesy of Jackson Township Historic Commission.)

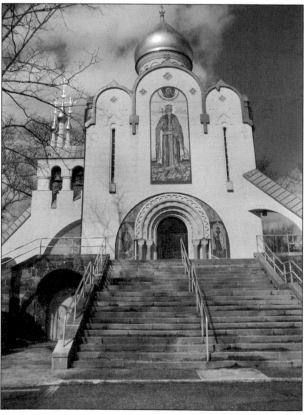

The Cassville section of Jackson saw an influx of Russian immigrants to the region in 1934, and they formed the Russian Consolidated Mutual Aid Society of America (ROVA). The Russian section of Cassville has since been known as ROVA Farms. St. Vladimir Memorial Church was built on the site of a 19th-century Presbyterian church on land owned by the Van Hise family. In 1938, the cornerstone of the Russian Orthodox Church was laid, and construction began in 1940. St. Vladimir was not completed until 1988, just in time for the millennium celebration honoring Vladimir of Kiev, who introduced Christianity to the Slavic people in 988 A.D. (Photograph by Victoria O'Donnell.)

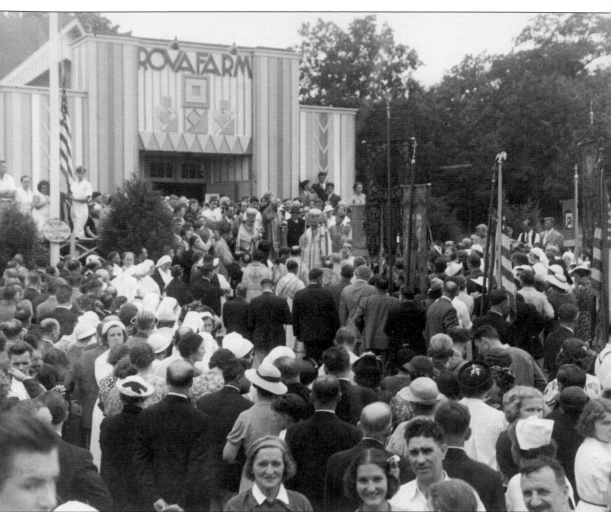

Russian immigration to the Ocean County area began in the late 1800s. The Rova Farm Resort, Inc., began as a tourist attraction in the 1930s when Russian immigrants arrived in Cassville. Originally 1,400 acres, the land was purchased from the Van Hise family. They formed the Russian Consolidated Mutual Aid Society of America (ROVA). A recreation area was built complete with a restaurant, school, library, and a pavilion. Many city workers would utilize this spot as a countryside retreat. Many children enjoyed various activities such as swimming, basketball, and baseball. They also had the opportunity to attend summer camp, where they learned about their culture and heritage. Rova Farm Resort, Inc., was established in 1934 as a social organization to promote the appreciation of the Russian culture and heritage. The year 1938 marked the 950th anniversary of the baptism of the Russian people, the same year the cornerstone was laid for the St. Vladimir's Memorial Russian Orthodox Church. Thousands of people arrived to celebrate the event, shown here. Construction began a few years later, much to the credit of Archbishop Vitaly. (Courtesy of Rev. Fr. Alexander Smida, St. Vladimir's Memorial Church.)

The church site was originally the location of a Presbyterian church. The construction of the church was made possible through church collections and was built mostly by Russian immigrants. After Archbishop Vitaly passed away, Archbishop Nikon continued his mission. Neither man would see the final completion of the church, which happened in 1988. St. Vladimir's Memorial Russian Orthodox Church stands just a short distance from the Rova Farms Resort, Inc., in Cassville. (Courtesy of Rev. Fr. Alexander Smida, St. Vladimir's Memorial Church.)

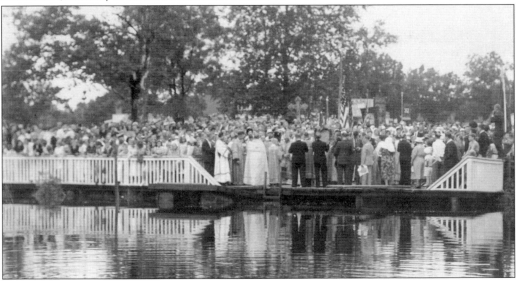

This photograph displays the St. Vladimir's Day ceremony held in the summer of 1938. St. Vladimir's Day is celebrated in late July and once gathered up to 50,000 people. In the 1960s, the Russian population declined and the pavilion was torn down because renovation was too costly. Today, efforts are being made to preserve the culture and history of the Rova Farm Resort. (Courtesy of Rev. Fr. Alexander Smida, St. Vladimir's Memorial Church.)

Four

RECREATION

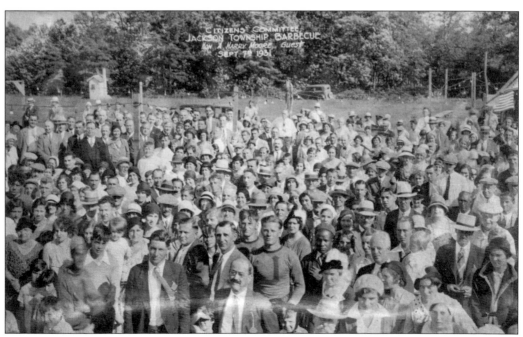

In 1931, the Jackson Township Citizens' Committee Township Barbeque was held, and the Honorable A. Harry Moore attended. Moore was elected governor of New Jersey that November and took office the following year. (Courtesy of Jackson Township Historic Commission.)

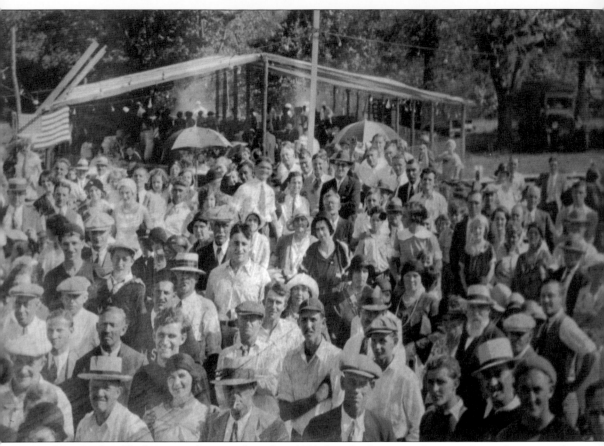

Hundreds of Jackson residents gathered in 1931 for a barbeque and enjoyed an afternoon of eating, drinking, and socializing with friends and neighbors. Here, the crowd is shown enjoying the festivities in what is generally considered to be the inspiration for Jackson Day, the township's annual celebration. (Courtesy of Jackson Township Historic Commission.)

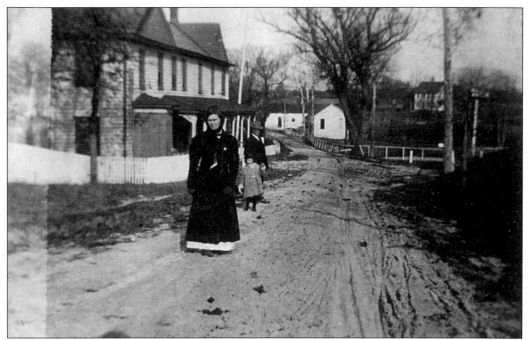

A woman strolls down the road in the early 1900s near a building that would become Rac's Hut, a cultural hub of Jackson Township. Rac's Hut hosted legendary musical performances by the likes of Patsy Cline and George Jones throughout the late 1950s and 1960s. (Courtesy of Jackson Township Historic Commission.)

The old Poppe barn stood for over a century off what is now Bowman Road. When the barn was torn down, the Ocean County Department of Parks and Recreation transformed the 88 acres into Patriots Park, which provides athletic facilities and a playground. (Courtesy of Jackson Township Historic Commission.)

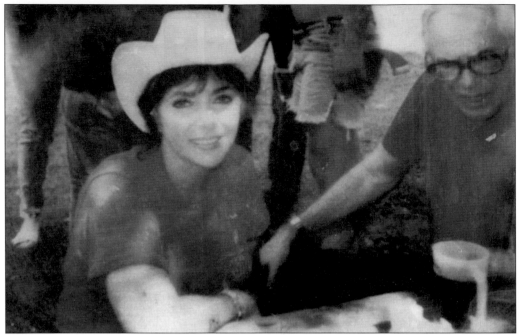

Legendary actress Elizabeth Taylor accompanied financial magnate Malcolm Forbes to Jackson on a motorcycle in 1987 to raise money for AIDS research. In this photograph, Taylor enjoys a cold drink outside of Just Plain Jane's on the hot August day. (Courtesy of Jane McKracken.)

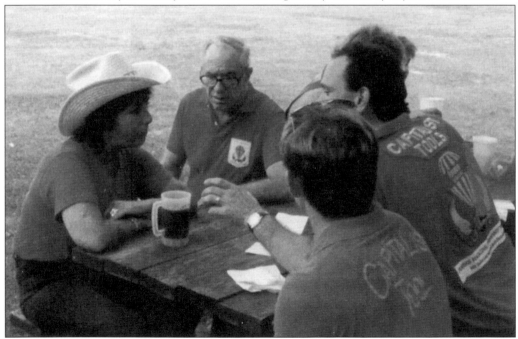

Liz Taylor and Malcolm Forbes rode motorcycles from Forbes's estate in Somerset County to the Jersey shore to raise money and awareness in the fight against AIDS. The group stopped at Just Plain Jane's in Jackson for drinks and raised nearly $1,000 by passing a motorcycle helmet through the tavern for donations. (Courtesy of Jane McKracken.)

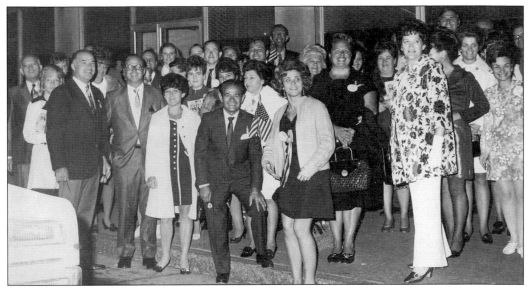

At the 1970 Miss America Pageant in Atlantic City, former Jackson resident Lisa Donovan was Miss Florida. Pictured in the photograph are Jackson residents who traveled to Atlantic City to show Donovan their support. Although not all are identified, the crowd of well-wishers included Lee Ebert, Eleanor Hyres, Herb Dolan, Kay Dolan, Mike Rytlewski, Ralph Finelli, Jim Hyres, Elizabeth Suanno, Ann Finelli, Lorraine Rytlewski, Ray Wilson, Theresa Suanno, Mrs. Polina, Sam Polina, Frank Morra, Loretta Fabriszak, Alga Janosz, Agnes Hordeman, Larry Lupinski, and Donald Bates. (Courtesy of Jackson Township Historic Commission.)

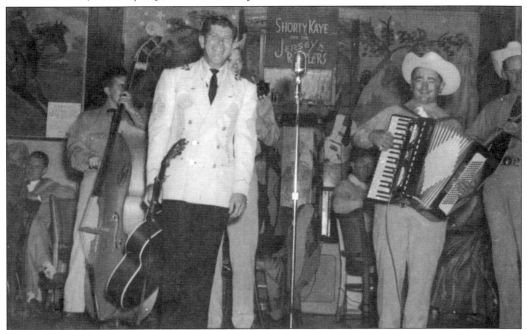

Shorty Kaye was one of the many accomplished country and western artists who frequently played at Rac's Hut in Jackson between recording sessions in New York City. Kaye, whose real name is Milton Kovacofsky, is pictured here playing the accordion. Shorty Kay settled in Jackson and was still playing local gigs into his 80s. (Courtesy of the Lorraine Applegate collection.)

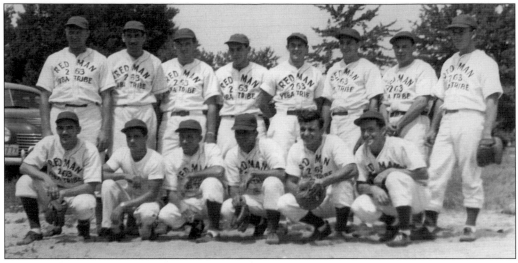

The Jackson Mills Redman's Lodge Yuba Tribe 263 baseball team is pictured here in 1947. They included, from left to right, (first row) Ben Benjamin, Tony Ercolio, Orville Davidson, Ray Davidson, Mel (Babe) Kiebler, and "Buzz" Horner; (second row) John Kiebler, Jim White, Paul Hendrickson, Jack Singer, Johnny DeSider, George Booze, Borden Applegate, and Warren Childers. (Courtesy of the Lorraine Applegate collection.)

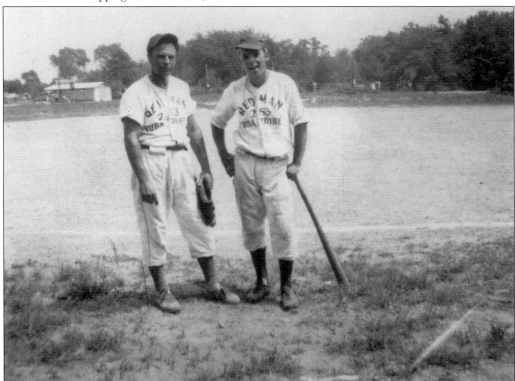

Pictured here are Ed Weber (left) and Borden Applegate (right), two members of the Redman baseball team. The team was active from 1947 to 1950 and played their home games behind Applegate's General Store in Jackson Mills. In a time before televised baseball, many local residents gathered to watch the games on Sunday afternoons. (Courtesy of the Lorraine Applegate collection.)

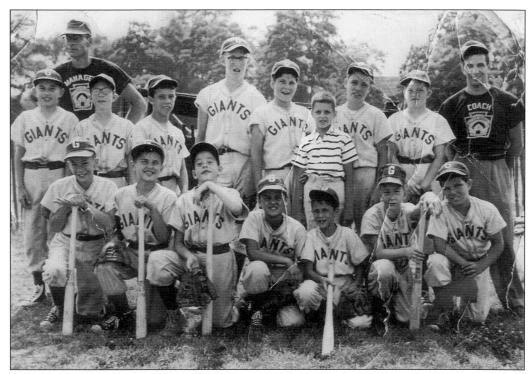

Jackson's first Little League baseball team was founded in 1957, playing its first season in 1958. The Jackson Little League had a total of four teams, including the 1958 Giants. Pictured are, from left to right, (first row) Ray Gibson, Bill Bartolf, Richard Zimmerman, Roy Greenhagh, Mickey Monohson, Paul Zimmerman, and Nick Infurna; (second row) Mike Bartoff, Neil Rogove, Jim Infurna, Ralph Rogove, Rich Lanko, Frank Oliva, Joe Russell, and Charles Moore; (third row) manager Neil Rogove and coach Nat Infurna. (Courtesy of Rich Lanko.)

The Holbrook Little League was formed in the early 1960s, and the players shown here were the 1969 All Stars. No fewer than six members of this team played on coach Larry D'Zio's 1972 state championship team at Jackson Memorial High School. It was the first state championship in the history of Jackson Memorial High School. Pictured are, from left to right, (first row) unidentified, Ted Burke, George Alvarez, Phil Kornbluth, Ken Sims, and Joe Migliore; (second row) two unidentified, Tom Flynn, John Sorge, Tom Darwell, Rick Paynter, Mark Mendelson, John Langford, Steven Ginsberg, and unidentified. (Courtesy of Ken Sims.)

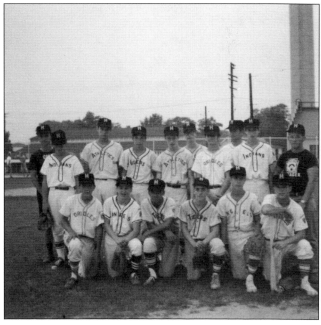

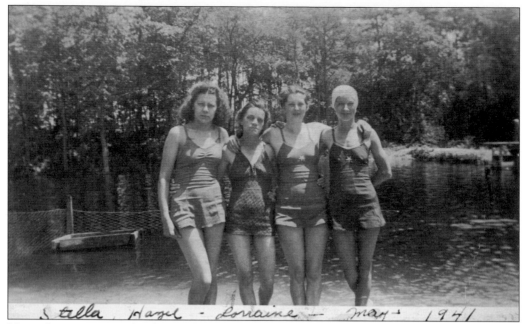

Stella, Hazel - Lorraine - May - 1941

Many days were spent by the Applegate Lake, located near the Applegate General Store, past Redman's ball field, down a sandy pine road. Area residents relaxed on the beach area and cooled off in the lake on hot summer days. Shown here in 1941 are Stella ?, Hazel Hendrickson, Lorraine Applegate, and May Applegate. (Courtesy of the Lorraine Applegate collection.)

Applegate Lake was built by William Applegate behind his general store. In 1934, Applegate purchased the store from the Wagonstein family, who had acquired it some years earlier from the Simmon family. Amenities included a diving board, a fireplace, wooden dance floor, and a picnic area with benches. A wooden outhouse was also built on the property. Many local residents assisted Applegate with the construction of the lake, including Frank Gordon, William's son Borden, and "Taters" Davison. The image here was taken in 1949 in the picnic area. (Courtesy of the Lorraine Applegate collection.)

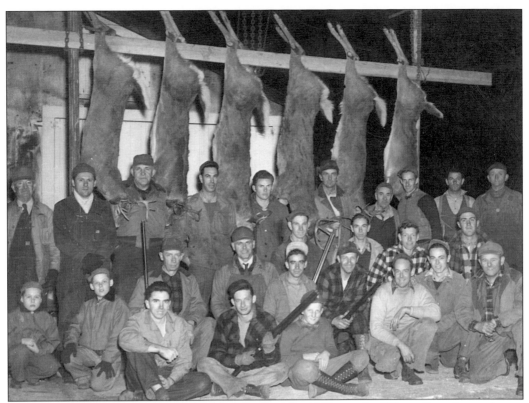

This photograph of the Gibson Gang was taken in the 1940s on the Gibson farm, located next to the Holmansville Church. The group shown here includes Sarge Yasuk, John Yasik Jr., Frank Holman Jr., Fred Dennis, Frank Holman Sr., Joe Peterson, Ray Gibson, Henry Gibson, Harold Gibson, Bob Haines, Milton Busby, John Yasuk, Charlie Peterson, Bob Gibson, Ted Thompson, Jerry Showell, George Gibson Sr., Todd Holman, and George Gibson Jr. (Courtesy of Daniel J. Black.)

Many Jackson men were members of hunting clubs in town. The township map of 1967 shows at least nine active hunting clubs. In 1963, members of the Olympic Buck Club met at the John and Sue Stamos residence. Some of the members include John Bye, Tuillo Landi, Donald Landi, Harold VanArsdale, Lou Stamos, Jerry Lanko, Pete Stamos, and Nickolas Shestakow. (Courtesy of Rich Lanko.)

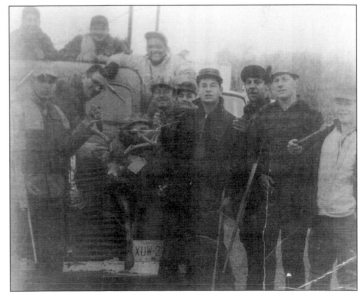

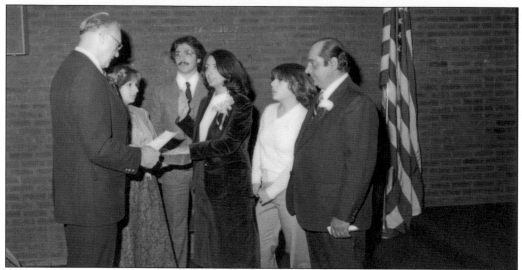

Arleen Polito is sworn in as Jackson's first female mayor in 1979, becoming one of the first women in New Jersey to be elected to that office. Polito worked for 18 years with special education students in Jackson Schools and enjoyed a long and distinguished career of service in Jackson, including stints as police commissioner and president of the board of education. (Courtesy of the Polito family.)

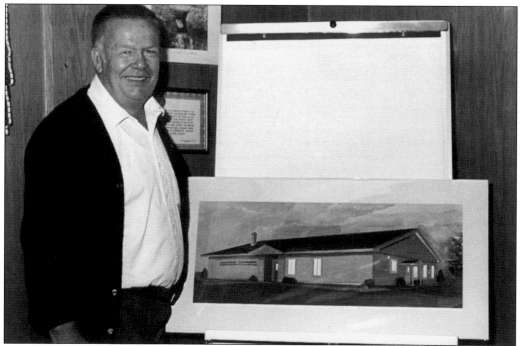

Lifelong Jackson resident Melvin Cottrell poses with an artists' rendering of the Jackson Township Senior Center that would eventually bear his name. Cottrell was involved in public service at township, county, and state levels for more than 30 years. He spent 10 years in the New Jersey General Assembly and served as the state chair of the Senior Issues and Community Services Committee. In addition, Cottrell spent six years on the Jackson Township Committee, including two years as mayor and five years as Jackson Board of Health chair. (Courtesy of Jackie Cottrell-Burns.)

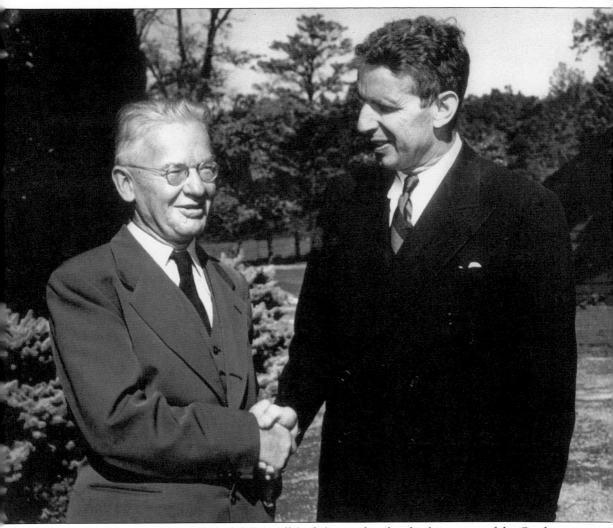

Former New Jersey governor Alfred E. Driscoll (right) served as the chief executive of the Garden State from 1947 to 1954. He is shown here with Stanley Switlik at the April 1951 dedication of Lake Success, the largest lake in Colliers Mills. Switlik donated to the state most of the acreage that became the Colliers Mills Wildlife Management Area. (Courtesy of Jackson School District.)

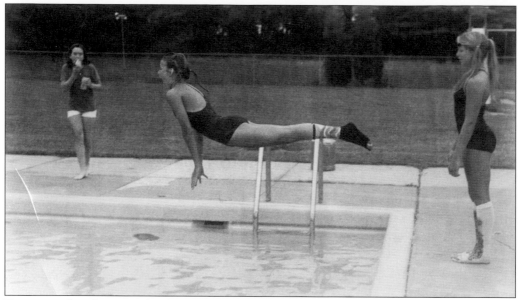

For over a decade, many families spent their summer days at Camp Holbrook. The YMCA of Ocean County operated their swim club at Camp Holbrook, later known as Camp Joy. The land had been donated by township resident Waldo Holbrook. The camp was 26 acres and had three pools, a snack bar, pavilion, tennis court, and picnic area. Children enjoyed all of the amenities. In the evenings, swimming and diving classes taught by Dolores Kraft-Regnault were available for adults. Kraft-Regnault also coached the YMCA's swim team. Shown here, Jeanie Kraft dives in as her sister Lisa prepares to follow. (Courtesy of Dolores Kraft-Regnault.)

Dolores Kraft-Regnault's affiliation with the YMCA began when she was a visitor at Camp Holbrook, also known as Camp Joy. Kraft-Regnault (center) began her career as a swim instructor at the YMCA back in the 1960s. Although the YMCA in Jackson closed in 1972, she taught many Jackson children to swim over the years, and she continues to teach water safety at the Ocean County YMCA. (Courtesy of Dolores Kraft-Regnault.)

Five

TRANSPORTATION

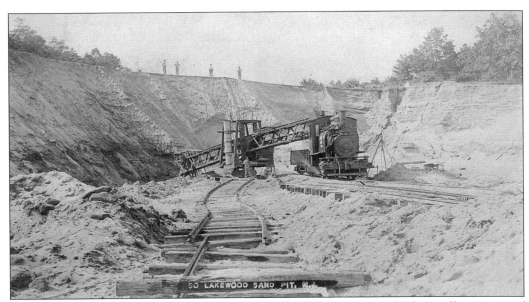

The railroad reached Jackson in the latter half of the 19th century, and Whitesville was one of the stops. The South Lakewood station would eventually be built near where this path was carved through the sandstone. (Courtesy of Jackson Township Historic Commission.)

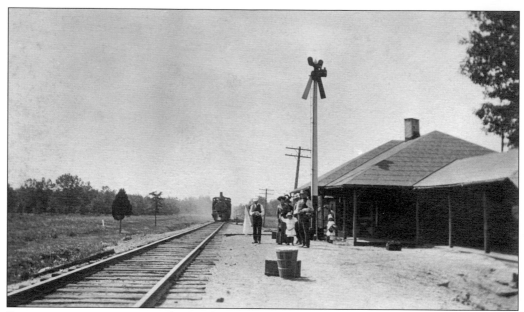

Passengers awaiting a train at the South Lakewood station were photographed here around 1900. Located on the corner of Whitesville Road and Faraday Avenue, the station quickly became the hub of Whitesville. (Courtesy of Jackson Township Historic Commission.)

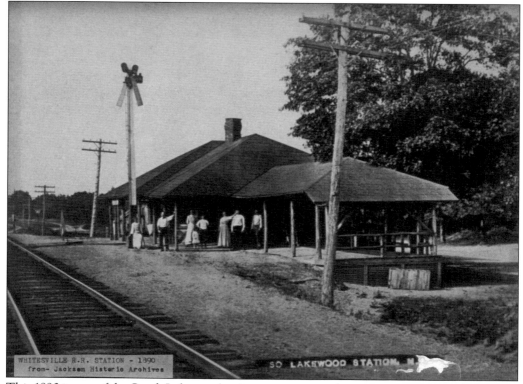

WHITESVILLE R.R. STATION - 1890
from- Jackson Historic Archives

SO. LAKEWOOD STATION, N.

This 1890 image of the South Lakewood train station captured passengers waving to the camera. In 19th-century life, few things brought such commotion and excitement as a train arriving with people, goods, and possibilities. (Courtesy of Jackson Township Historic Commission.)

The entrance to the South Lakewood train station in Whitesville is pictured in this 19th-century photograph. Note that there is only one track, and it looks like the bench is in pretty rough shape! (Courtesy of Jackson Township Historic Commission.)

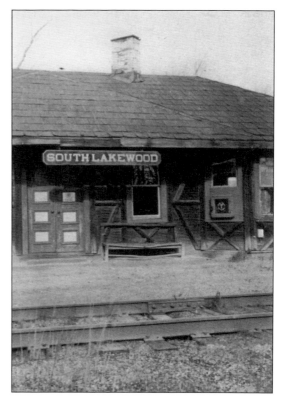

For many years, a stop at the South Lakewood train station would lead to a conversation with station agent Buzby, who not only worked at the station, but lived in close proximity with his family. (Courtesy of Jackson Township Historic Commission.)

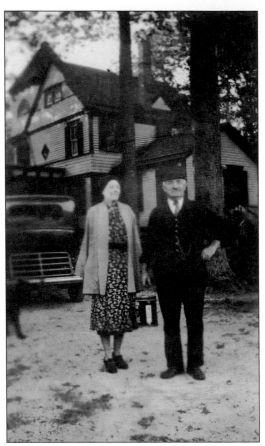

South Lakewood station agent Buzby and his wife pose in front of their home in Whitesville. Buzby lived across the street from the station, which he may or may not have been going to paint. (Courtesy of Jackson Township Historic Commission.)

Members of the Buzby family pose for a photograph. The family had a farm off Whitesville Road and shipped produce via the South Lakewood train. (Courtesy of Jackson Township Historic Commission.)

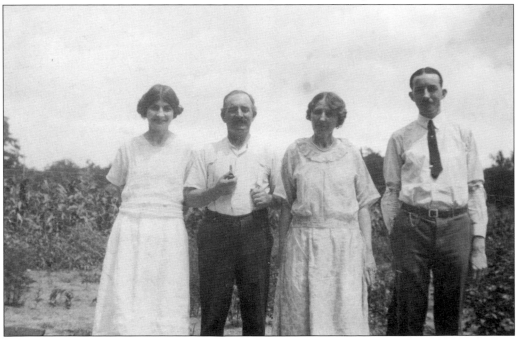

When Buzby was not at the South Lakewood station, he spent time working on his farm. Here, the Buzbys are pictured with a young boy. (Courtesy of Jackson Township Historic Commission.)

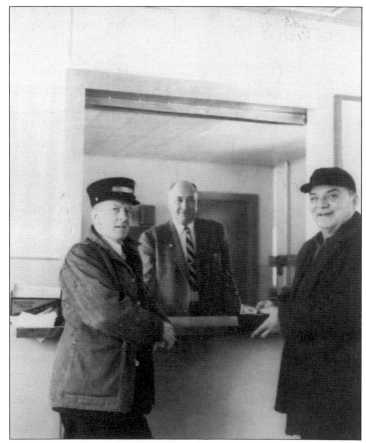

Another day at the train station in Whitesville. In this 1950s photograph, a man cheerfully purchases a train ticket. (Courtesy of Jackson Township Historic Commission.)

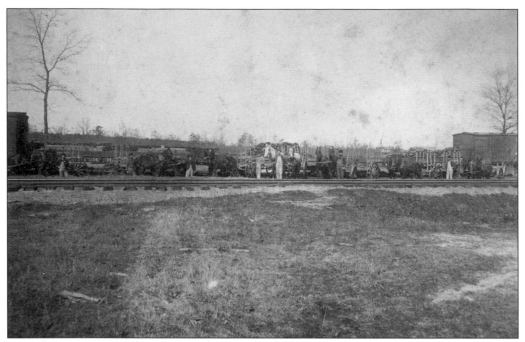

The railroad was the lifeblood of the American economy in the 19th century. Residents from near and far would await a train to buy, sell, or ship goods and resources from the South Lakewood station in Whitesville. (Courtesy of Jackson Township Historic Commission.)

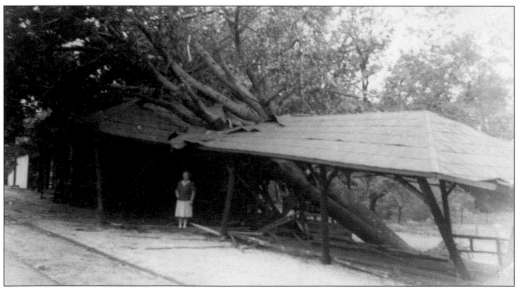

Around 1960, long after trains had stopped coming through Whitesville, a massive tree fell on the South Lakewood station. All that remains of the station today is an empty loading track. (Courtesy of Jackson Township Historic Commission.)

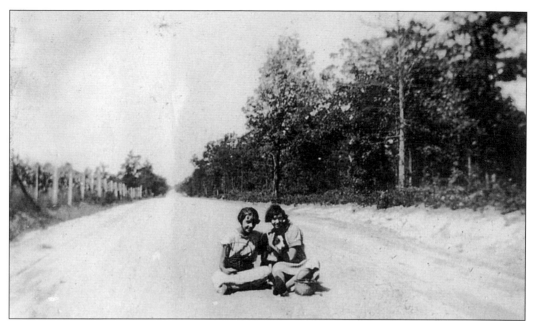

Prior to widespread use of automobiles, children could safely play on dirt roads throughout the sparsely populated town. In this 1924 photograph taken on Trenton Road, two girls holding picnic baskets are enjoying the afternoon. Residents no longer picnic on this stretch of road, as it is now the heavily traveled Route 526. (Courtesy of Jackson Township Historic Commission.)

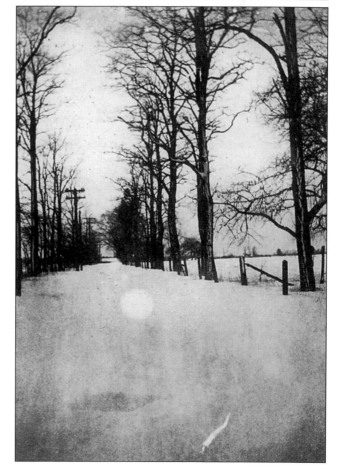

Shown here is an early-20th-century photograph of snow-covered New Prospect Road. The photographer is facing north and probably was quite chilly at the time. (Courtesy of Jackson Township Historic Commission.)

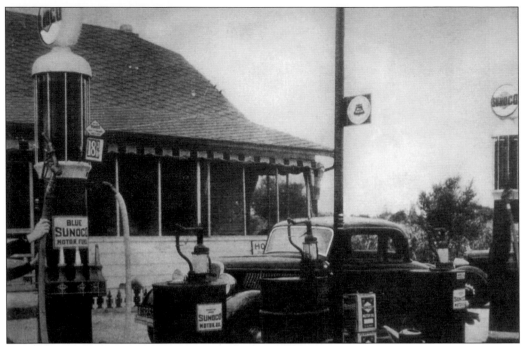

The major reason why Whitesville's train station closed was the automobile. This photograph shows a car filling up at the Glasco station in Whitesville in 1938. This customer paid 18¢ per gallon for Sunoco gasoline. (Courtesy of Jackson Township Historic Commission.)

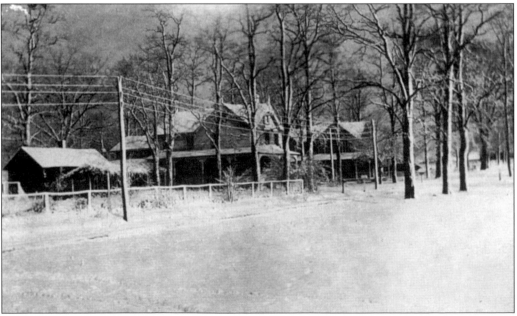

Several homes located on New Prospect Road were photographed near the turn of the 20th century. Telegraph and later telephone wires have spanned the length of New Prospect Road for a century and a half. (Courtesy of Jackson Township Historic Commission.)

Six

FIRE DEPARTMENT

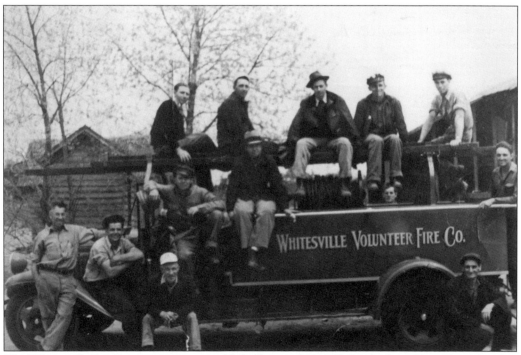

The Whitesville Fire Department was established around 1931. Before Jackson Township's first fire department was established, residents relied on fire companies from neighboring towns. Among the first volunteer firemen at Whitesville, seen above, are charter president George C. White, first vice president Frank B. Holman, treasurer Joseph Peterson, recording secretary Charles Estlow, first fire chief John Onley, and assistant chief Orsie Chambers. (Courtesy of Whitesville Fire Department.)

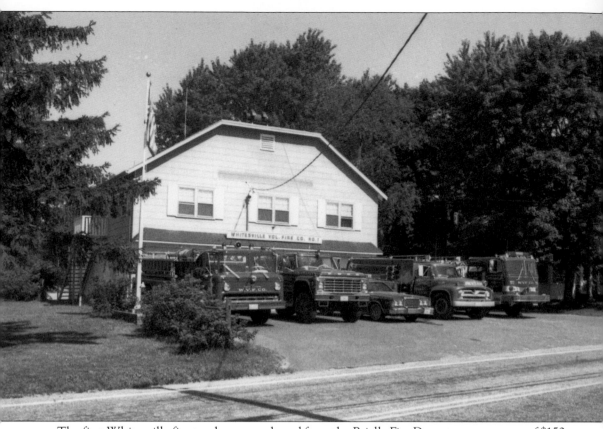

The first Whitesville fire truck was purchased from the Brielle Fire Department at a cost of $150. It was initially garaged at the Glasco station and general store. Fundraisers such as oyster and roast beef suppers were conducted to raise money to purchase new equipment. Shown here is the old firehouse with its fleet of trucks. (Courtesy of Whitesville Fire Department.)

On May 31, 1951, members of the Jackson Mills Fire Department laid the cornerstone for the firehouse. Shown here, department members unload cinder blocks that will become the station building. Pictured are, in no particular order, Morgan Hendrickson, Jack Perry, Borden Applegate, Ottie Hendrickson, John Steeb, and Howard Gustafson. (Courtesy of the Lorraine Applegate collection.)

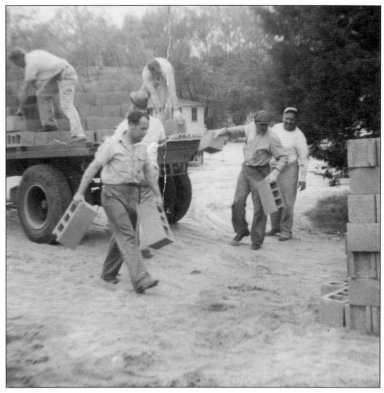

The dedication of the new Jackson Mills Firehouse was held on October 4, 1992. John Smatusik, pictured here, gave a speech on the history of the department. Smatusik was a charter member of the Board of Fire Commissioners for Jackson Mills Volunteer Fire Co. Station 54. A lifelong township resident, Smatusik was an active member of the community, serving as a member of the Rotary Club, VFW Post 4703, Township Committee, Jackson Township Historic Commission, and Alumni Hall of Fame. He was also an honorary member of the First Aid Squad, president of the Jackson Little League, and superintendent of the Public Works Department for three decades. Smatusik proudly served in the US Army during World War II. He received the Army of Occupation Medal and the World War II Victory Medal. (Courtesy of the Lorraine Applegate collection.)

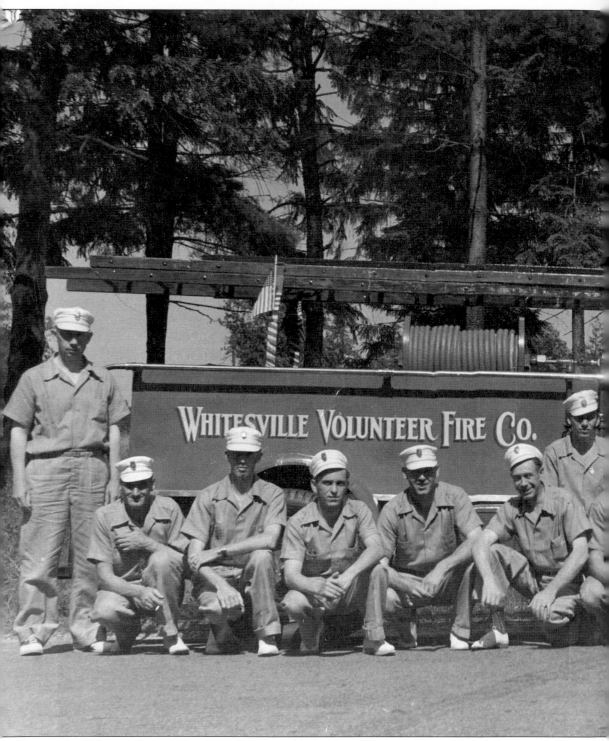

The Whitesville Fire Department was established in 1931. The first volunteer firemen were, from left to right, (first row) Brower Holman, Merrill White, Henry White, Joe Smelling, Joe Peterson, Stanley Moor, Donald White, Kenneth Grover, Arthur Chambers, Harold Stevens,

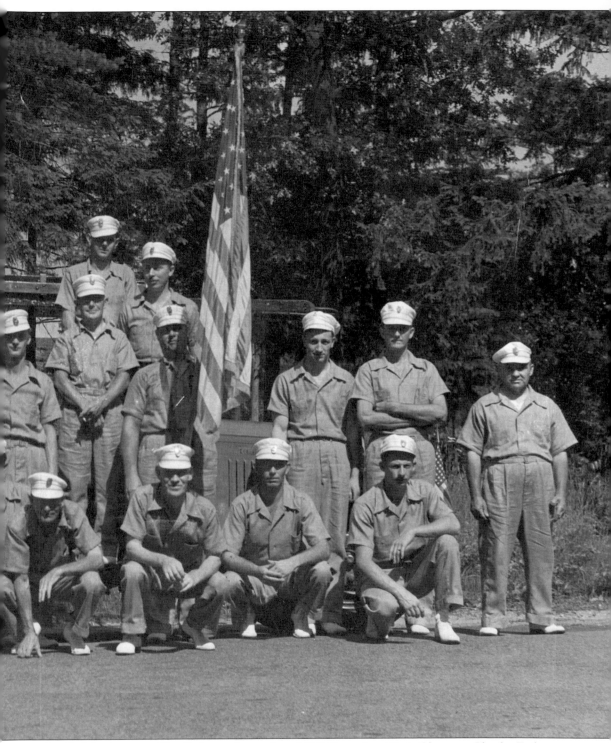

Orville Matthews, and Jay Holman; (second row) Bill Grunning, Orsie Chamers, Charles Estlow, unidentified, Jerry Showell, and Nick Julio; (third row) Ernest Bruce and unidentified. (Courtesy of Joe and Diana Burdge.)

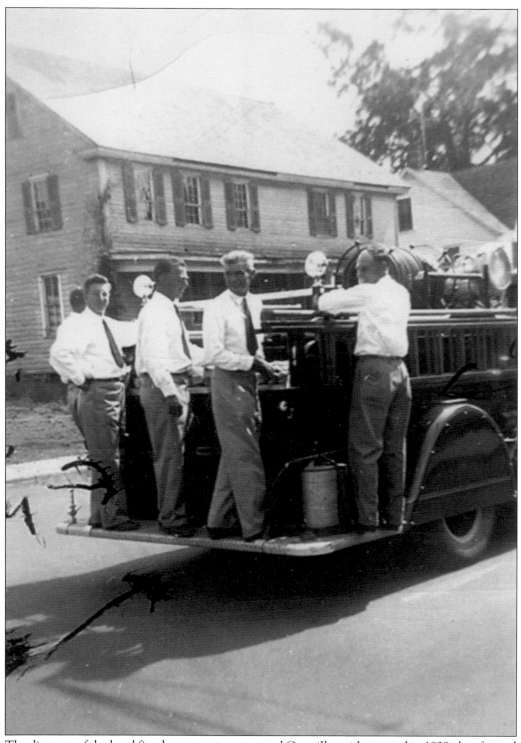

The distance of the local fire departments concerned Cassville residents, and in 1939, they formed their own volunteer station. Several of the Cassville volunteer firemen were photographed along a parade route. (Courtesy of Wally and Ginny Jamison.)

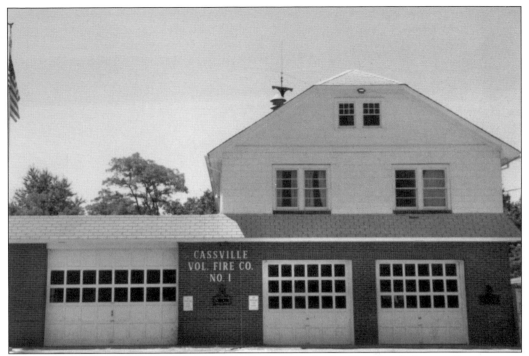

As America fought the Second World War, Cassville worked to build its first firehouse. Construction started in 1943 and was completed in 1946. Shortly after the great fire of 1963, the Cassville firehouse experienced its own blaze, but the damage was repaired and portions of the structure were rebuilt. (Courtesy of Wally and Ginny Jamison.)

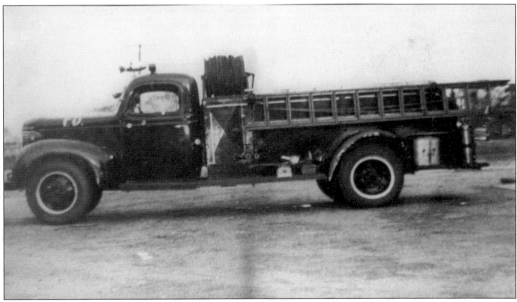

The first fire truck acquired by the Jackson Mills Fire Department was a 1939 Dodge. The truck was purchased from the state forest fire service for $375. Fire company members rebuilt the truck, and it was put into service by the summer of 1951. (Courtesy of the Lorraine Applegate collection.)

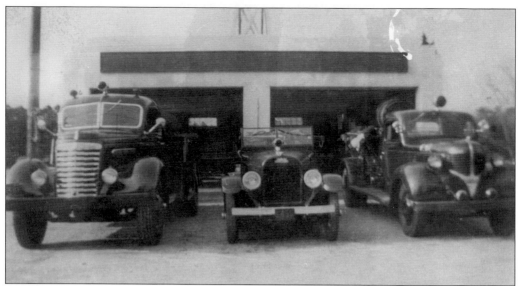

The first three fire trucks purchased for the Jackson Mills Fire Department included a 1939 Dodge, a 1928 REO, and a 1950 GMC truck. (Courtesy of the Lorraine Applegate collection.)

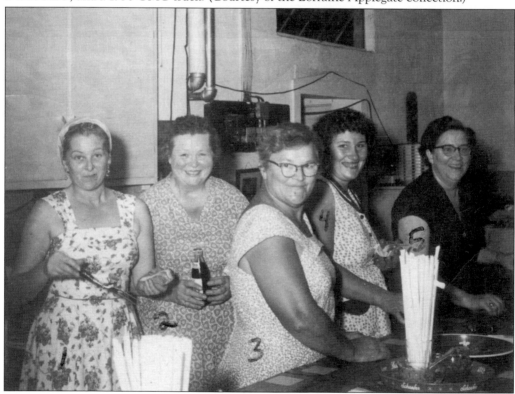

The Ladies Auxiliary held fundraisers to collect money for the fire company. A typical function would include dinner and entertainment to provide the Jackson Mills Fire Department with funding used to purchase equipment. Pictured here in their first kitchen are, from left to right, Lorraine Applegate, Winnie Matthews, Mae Schuster, Jane Ferro, and Eva Cottrell. (Courtesy of the Lorraine Applegate collection.)

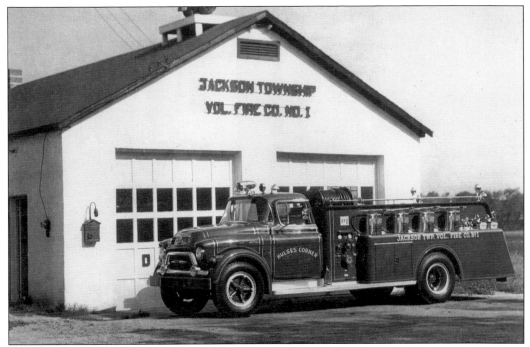

Jackson Township Volunteer Fire Company No. 1 is commonly referred to as the Larsen Road Fire Company or Jackson Station 55. Located on the corner of Larsen and New Prospect Roads, the station has been in operation for 50 years. In early days, it was known as the Hulses Corner Fire Company, as indicated on the truck door. (Courtesy of Station 55.)

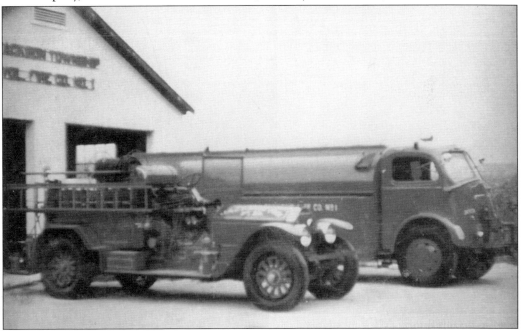

When the Larsen Road Fire Company was in its infancy, some of the early vehicles harkened back to an earlier time. In this photograph, two older vehicles are parked in front of the firehouse ready for action. (Courtesy of Station 55.)

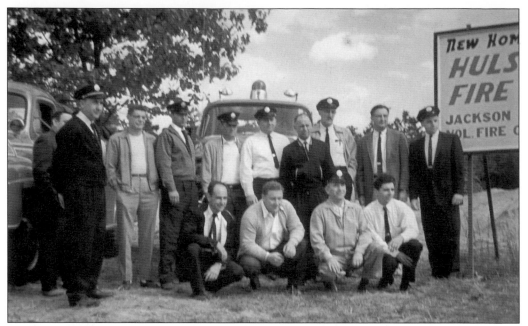

Fire department officials pose on the site of the future Larsen Road Fire Company. Ground was broken on Fire Station 55 in 1962, and it was put into service shortly thereafter. The sign shows the new station name as Hulses Corner Fire Station. (Courtesy of Station 55.)

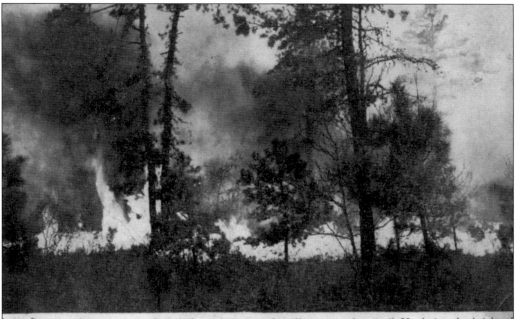

Forest fire rages in area near Jackson Mills, Jackson Township. Photo was taken April 20, during the height of the fires. 1963

Jackson experienced a severe drought in 1962 and was further compromised by a rainfall five inches below normal in the summer of 1963. Under these conditions, a fire was only a matter of time. When the tinderbox was finally lit by Mother Nature, 45-mile-per-hour winds quickly blew the small conflagration into what became known as the great fire of 1963. (Courtesy of the Lorraine Applegate collection.)

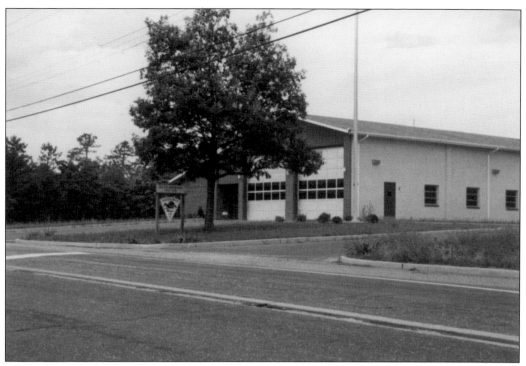

The Jackson Mills Fire Station is pictured here in the 1970s. The building continues to be used today as a substation, responding to alarms from Jackson Mills and the rest of town. It is located on Commodore Boulevard. (Courtesy of Borden Applegate.)

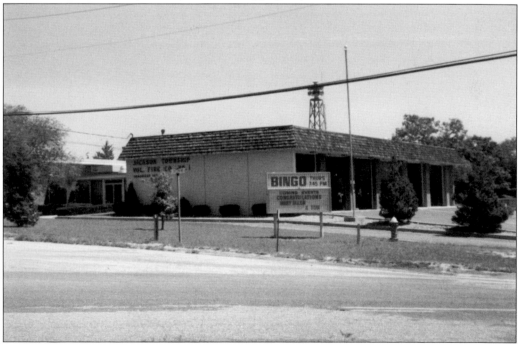

The Larsen Road firehouse is pictured in the 1970s. The firehouse, commonly known as Station 55, added fundraisers such as Bingo to help pay the bills. (Courtesy of Borden Applegate.)

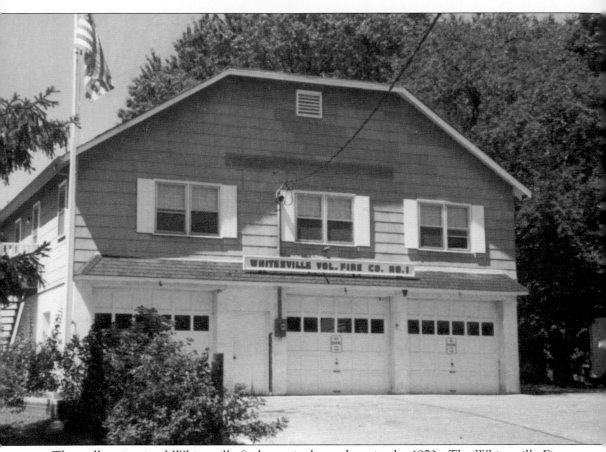

The well-maintained Whitesville firehouse is shown here in the 1970s. The Whitesville Fire Department was founded in 1931. (Courtesy of Borden Applegate.)

Seven

POLICE DEPARTMENT

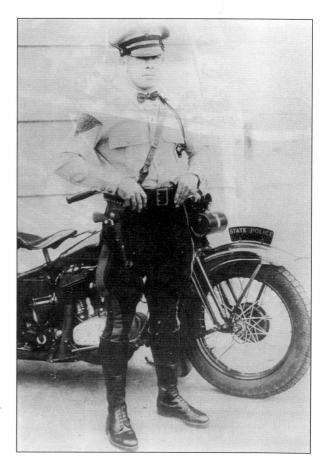

Lt. Frank Long was a New Jersey state trooper stationed in New Egypt and a Jackson resident. With no local police force to patrol Jackson Township, the municipality relied on the state police to serve the law enforcement needs of the community. After Long retired from the state police, he later became the township mayor. (Courtesy of Daniel J. Black.)

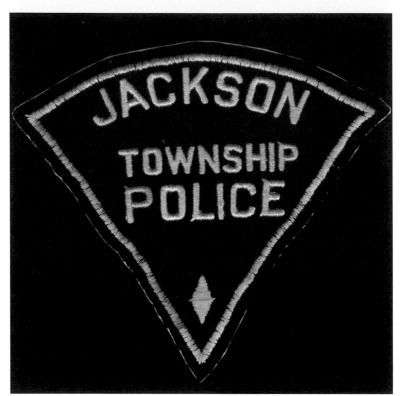

In the late 1940s, Jackson Township moved toward creating a full-time police force with the addition of a second officer. Shown here is the shoulder patch worn by members of the department during the 1950s.

Prior to 1946, an organized police department did not exist in Jackson. In the summer of 1935, Frank Booth was appointed as a special officer to patrol the Cassville corner two days a week at a salary of $2 per day. Booth was later named part-time police chief, a role he served in until he resigned in 1943. An official police department was created in Jackson Township in August 1946, and the Jackson Township Committee appointed Jerry Showell as the first police chief. Chief Showell is shown here standing next to his police vehicle at Norton's Esso gas station in Cassville.

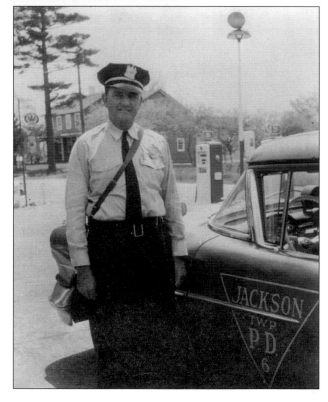

Before 1966, police headquarters was a 180-square-foot room located on the main floor of the municipal building, shown here. The detective bureau was in the basement. The facility had neither a jail nor an interrogation room, so offenders had to be transported to the county jail by two officers. The staff increased to 16 members before later moving to its new location.

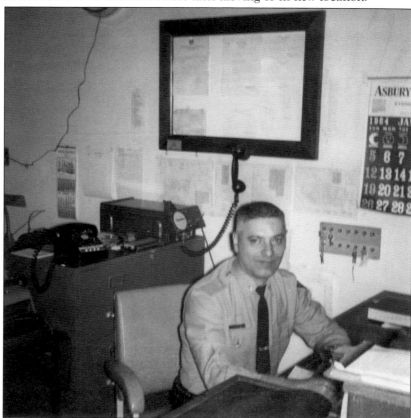

The one-room police headquarters was equipped with a police radio for the base station. Patrolman Louis DeMair is shown here manning the radio at the station.

In order to accommodate the growing 16-member force, police headquarters was moved to the old Korzen house, located across the street from the municipal building, in February 1966. The building was sold to Mr. and Mrs. Mike Koblin, who then leased it to the township for $265 per month. The Koblins were responsible for utilities and renovations. This building housed the police into the early 1970s and was torn down in the 1980s.

The initial design of the Jackson Township Police Department sign emulated a patrolman's shield. The sign in this photograph is nestled in a group of trees, indicating the rural surroundings of the Korzen house police station.

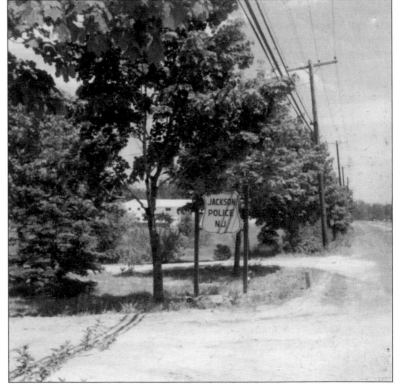

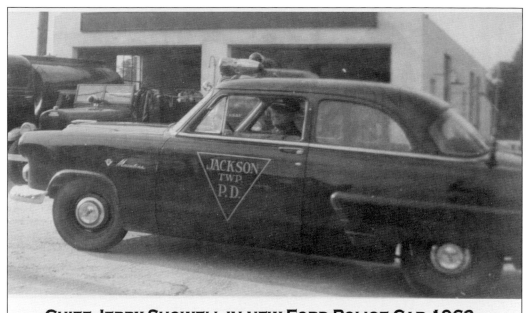

CHIEF JERRY SHOWELL IN NEW FORD POLICE CAR 1962 IN FRONT OF JACKSON MILLS FIRE CO.

Jerry Showell is shown here in front of the Jackson Mills Fire Department in a new police car around 1953. Tragically, Chief Showell drowned when his small boat capsized in Barnegat Inlet while he was fishing in 1962.

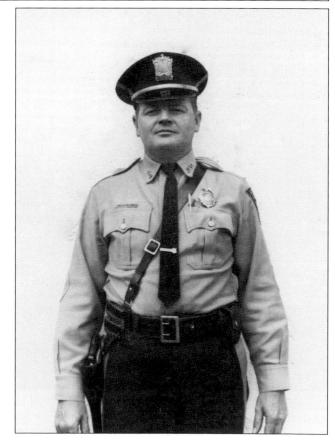

Walter McCurdy was appointed chief of police in 1962. Shown here, he began his career with the Jackson Police Department as a part-time special officer patrolling Jackson twice weekly. (Courtesy of the McCurdy family.)

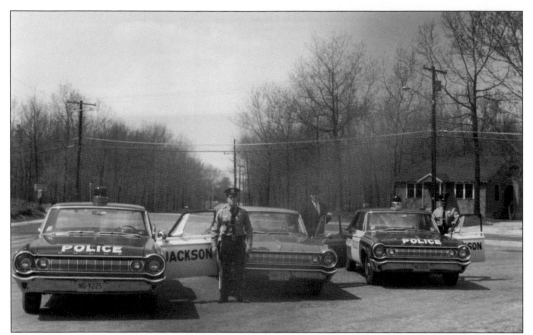

Throughout the 1960s, the Jackson Police Department steadily expanded from a staff of six to nearly 20 officers. At that time, the FBI recommended that communities hire one officer for every 500 residents. The officers shown here in the 1960s are standing by the new fleet of patrol cars. They are, from left to right, Borden Applegate, Bruce Cottrell, and Louis DeMair.

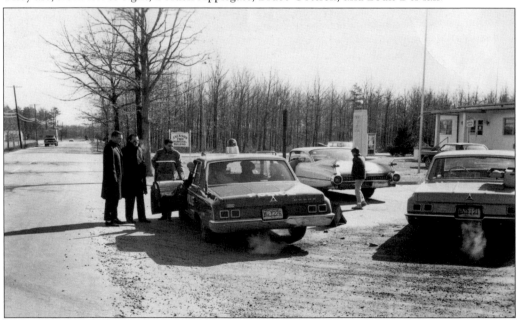

As the population steadily increased and technology began to have more of an impact on law enforcement, new equipment was purchased to ensure the safety of Jackson residents. Pictured are, from left to right, Commissioner Tanenbaum, Chief McCurdy, and patrolman Wentlejewski testing a newly acquired radar unit in front of the municipal building on West Veterans Highway in 1965.

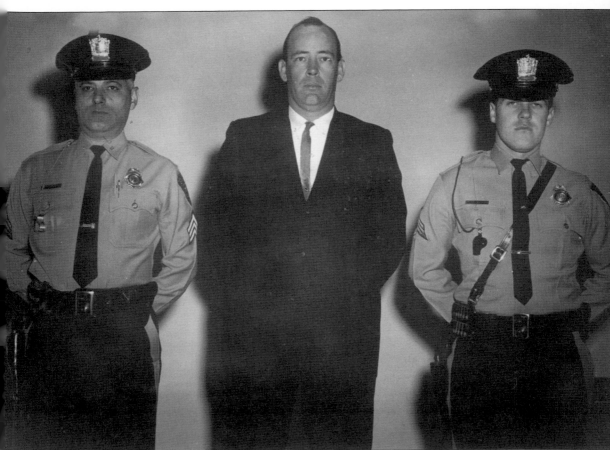

In 1964, Jackson Township promoted three new sergeants. From left to right are Louis DeMair, Bruce Cottrell, and Borden Applegate. After Bruce Cottrell retired, he became a Township Committee member, police commissioner, and mayor. Cottrell, business administrator William Santos, and public safety director Dick Chinery were the three men primarily responsible for the creation of the new Jackson Justice Complex.

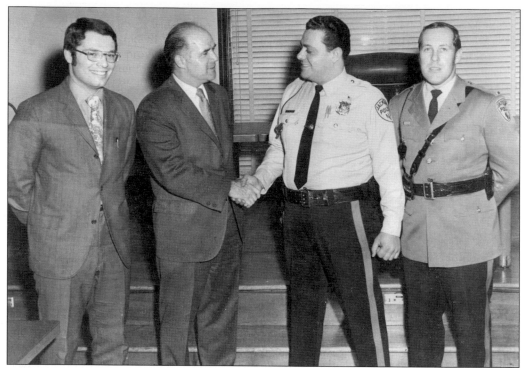

In 1972, Sam DePasquale graduated from the State Police Academy for Municipal Officers and joined Jackson's police force. Pictured from left to right are municipal business administrator George Gottuso, police commissioner Herb Dolan, patrolman Sam DePasquale, and acting chief of police Borden Applegate. DePasquale later became Jackson's second director of public safety.

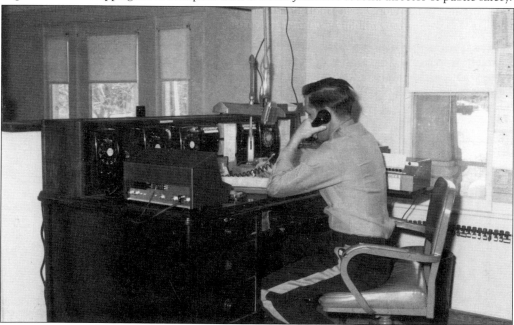

Shortly after moving to new police headquarters in the Korzen house in 1966, Sgt. Borden Applegate answers a call from one of the station's four phones while on desk duty.

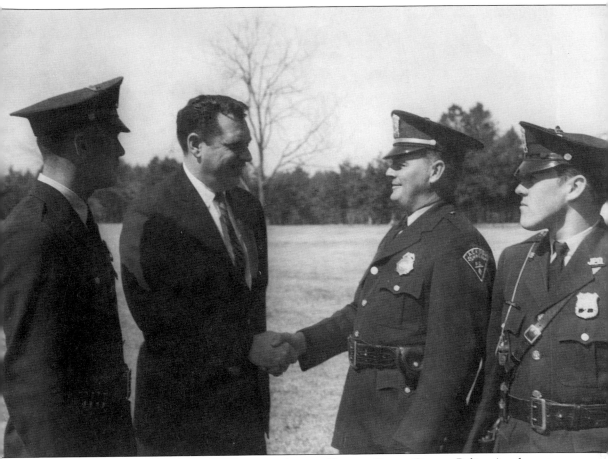

Freeholder Bob Miller is shown here congratulating officers at Ocean County Police Academy in the early 1960s. Shown from left to right are patrolmen Bruce Sloan, Bob Miller, Walter McCurdy, and Borden Applegate.

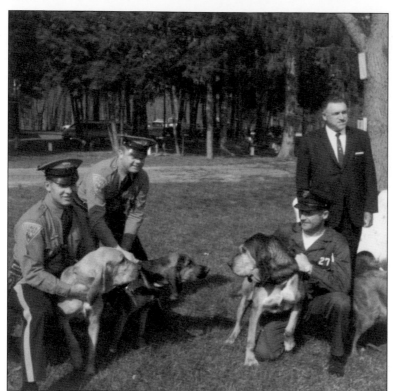

Ocean County Park was utilized to train police officers in the use of bloodhounds for tracking. This demonstration was held in 1965 at the former Rockefeller estate and was offered to officers across the region.

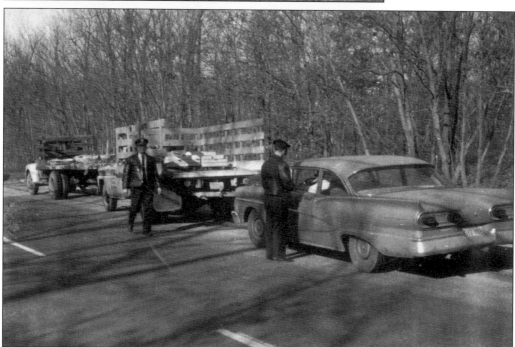

In the early 1960s, the Jackson Police Department occasionally set up roadside inspections for various purposes. In this 1963 photograph, officers conduct license inspections on New Prospect Road. Patrolman Borden Applegate is on the left, and Chief Walter McCurdy is on the right.

Walter McCurdy, police chief, stands by an unmarked vehicle at the new police headquarters in 1966.

Sgt. Borden Applegate guides students on a tour of police headquarters in 1967. There is a long-standing tradition of cooperation among educators and law enforcement personnel in Jackson.

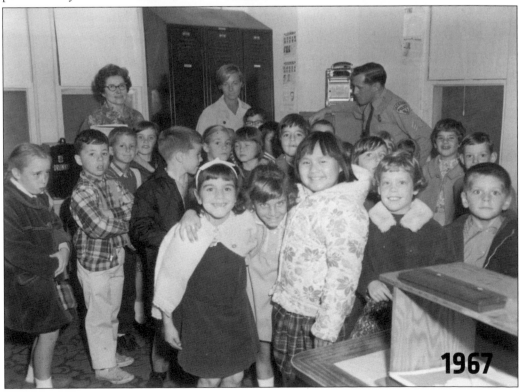

1967

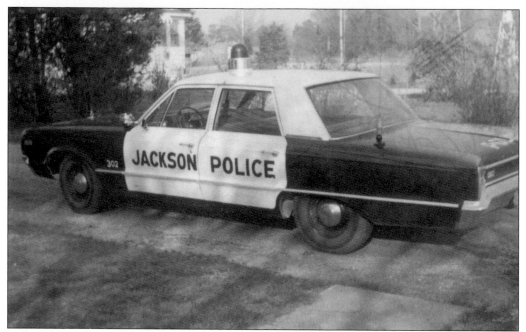

This 1966 police car was one of four that patrolled Jackson Township around that time. They patrolled a 102-square-mile district populated by 17,000 residents.

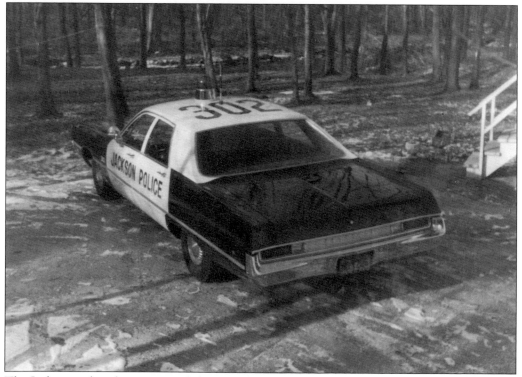

The Jackson police force mirrored the township and continued to grow throughout the 1960s. In 1969, Jackson Township added another new police car to the fleet. The number appearing on top of the car was added to identify cars from the air.

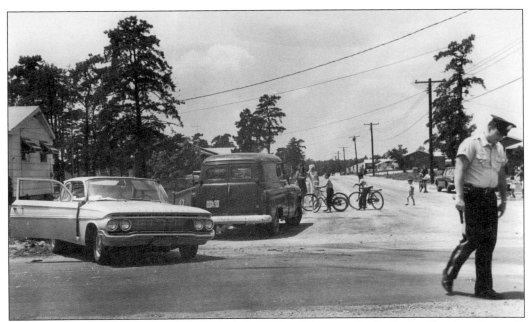

Patrolman Rich Dyott works the scene of an auto accident on Cooks Bridge Road in the mid-1960s. The somewhat undeveloped area in which the fender-bender took place is now known as Robin Estates.

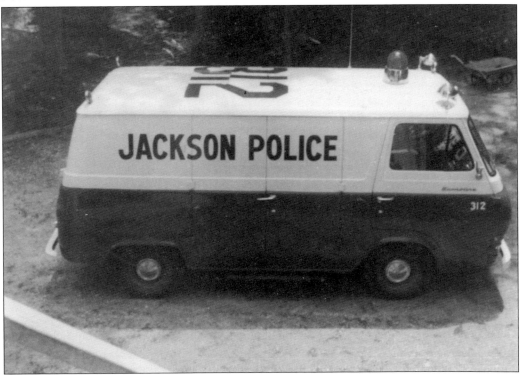

This newly equipped field operations van was acquired from the Jackson First Aid Department in 1969. The van performed a variety of services and proved to be a valuable acquisition for the Jackson Township Police Department.

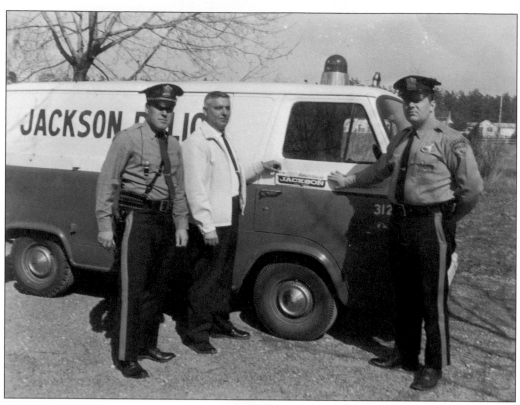

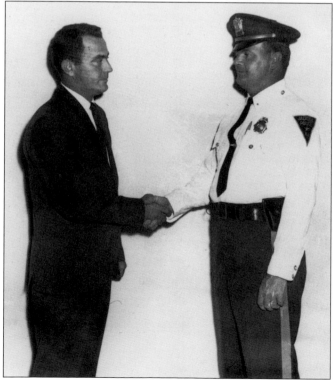

In 1969, Jackson Township celebrated its 125-year anniversary. In commemoration of this milestone, police department vehicles were adorned with bumper stickers provided by the Jackson Chamber of Commerce. Pictured here are, from left to right, Lt. Borden Applegate, Lt. Louis DeMair, and patrolman William Mulligan.

Chief Walter McCurdy is pictured here c. 1963 with Jackson Township Police Department detective Frank Hughes. (Courtesy of the McCurdy family.)

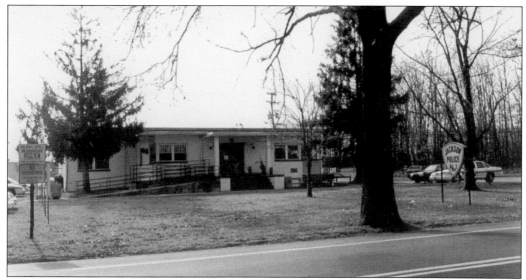

The police department moved its headquarters from the old Korzen house back to the former municipal building. However, conditions in the former building became dangerously unsafe, as the leaking roof, falling ceiling plaster, and sagging floor created an unproductive working environment. Headquarters would not be moved again until 1998, when it moved to the newly constructed Jackson Justice Complex. The official dedication of the Jackson Justice Complex took place on July 25, 1998.

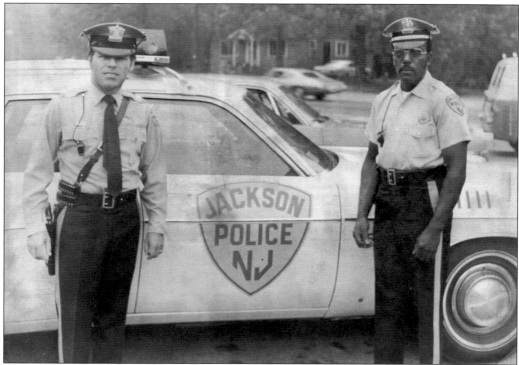

Acting chief of police Borden Applegate and Sgt. Bryant Evans display a new traffic safety station wagon, which was purchased in 1972. A federal grant allowed the township to purchase the new vehicle.

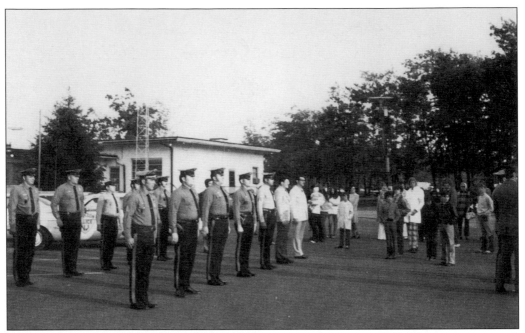

The Jackson police force is shown here undergoing an inspection in 1973. The inspection took place during National Police Week that year.

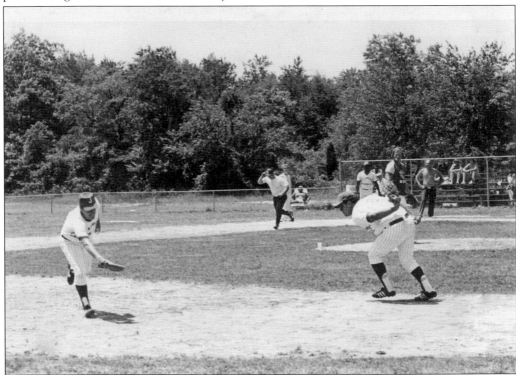

The police softball team is photographed during a 1977 game. Great Adventure sponsored the team and provided the new uniforms. In this photograph, the ball is hit between Borden Applegate (left) and Sam DePasquale (right).

Eight

TRIBUTE TO VETERANS

William White served in the Union army during the Civil War and lost his life at Gettysburg in July 1863. The Battle of Gettysburg was epic in its impact and its carnage. The battle raged for three days during which more than 23,000 Union troops and 28,000 Confederate soldiers were killed, wounded, or missing. White and the rest of the Union army finally helped prove that Lee's Army of Northern Virginia was not invincible, even if the fighting would not end until April 1865. There are close to 80 Civil War veterans interred in Jackson, with the 14th New Jersey Regiment having the most. (Courtesy of Jackson Township Historic Commission.)

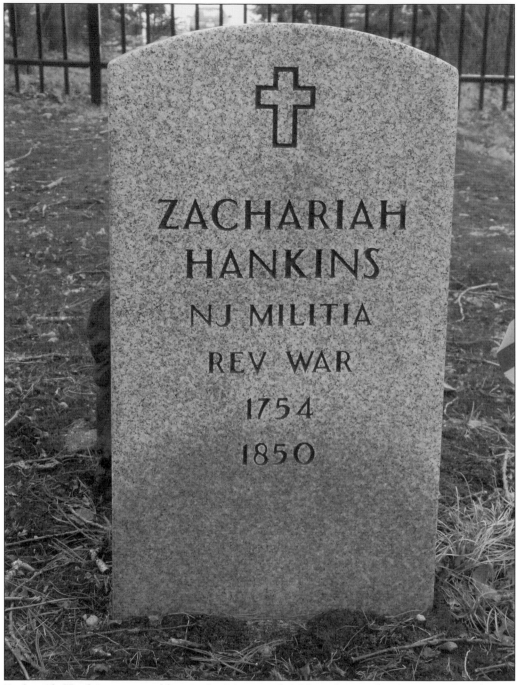

Zachariah Hankins was a soldier in the Monmouth Militia during the American Revolution. Under the command of Gen. George Washington, Hankins saw action at the Battle of Trenton in 1776, the Battle of Princeton in 1777, and the Battle of Monmouth in 1778. He died in 1850 at the age of 96 and was buried in the Cook Family Cemetery. Many of Hankins's descendants still live in the area. (Photograph by Christopher T. Ippolito.)

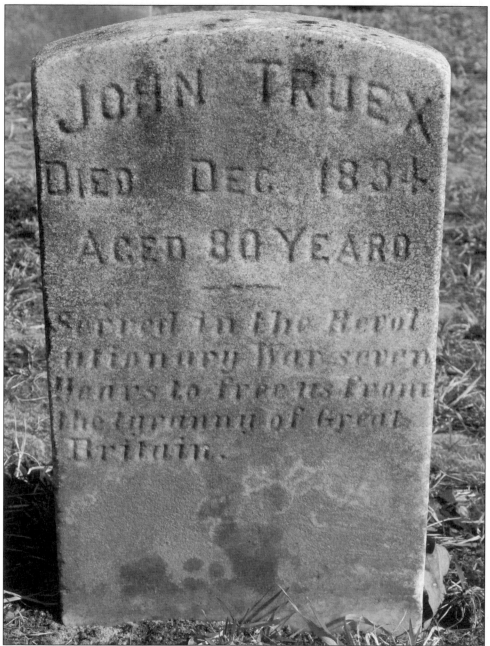

John Truex served in the American Revolution as part of the Continental 3rd New Jersey Regiment. The 3rd, known as the legendary "Jersey Blues," saw heavy action under the command of Col. Elias Dayton from Canada to Virginia. After training at Valley Forge under Baron Frederic von Steuben in the winter of 1777–1778, the 3rd New Jersey helped turn back the British at the Battle of Monmouth in June 1778. In 1781, Truex was with the 3rd New Jersey Regiment at the Battle of Yorktown and helped force a British surrender. He died in 1834 at the age of 80, and his grave is located in the old Cassville Cemetery in Jackson. His headstone reads: "Served in the Revolutionary War seven years to free us from the tyranny of Great Britain." (Photograph by Christopher T. Ippolito.)

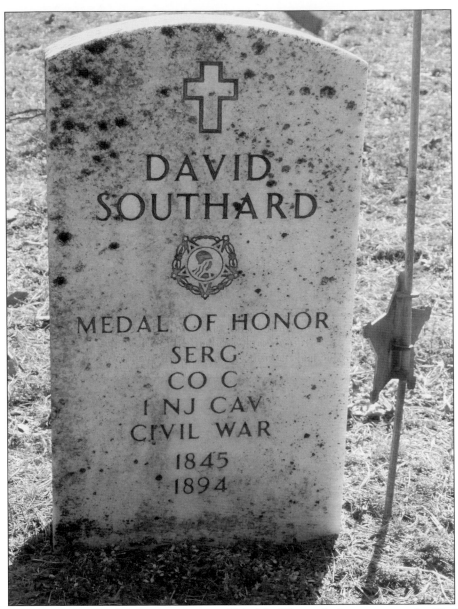

David Southard was awarded the Congressional Medal of Honor for his actions in the Civil War. Southard, who grew up in the Colliers Mills section of Jackson, enlisted in the 1st New Jersey Volunteer Cavalry in the summer of 1861 and served for the duration of the war. In 1864, he was promoted to corporal and then to sergeant. The 1st New Jersey was responsible for harassing Robert E. Lee's Army of Northern Virginia in early 1865. On April 6, Southard performed his act of bravery that earned him the Medal of Honor and pushed the Confederacy to the brink of surrender. Southard was one of a dozen members of his unit who bravely led a charge on Lee's forces at Sailor's Creek, and he was credited with capturing the Confederate flag. When the smoke cleared, the Union had captured more than 7,500 men, including several generals, leading to Lee's surrender at Appomattox Court House 72 hours later. Southard returned to Colliers Mills following the war and died in 1894. His grave is located at the Zion Methodist Church cemetery in New Egypt. (Photograph by Christopher T. Ippolito.)

Lifelong Jackson resident Wally Jamison was one of many who served with distinction in World War II. Jamison was awarded the Purple Heart and the Bronze Star for Valor during his tour in Europe. He was also awarded the French Legion of Honor Award, the highest award given by the French government, for his part in the liberation of France. (Courtesy of Wally and Marge Jamison.)

Many Jackson residents served in the US armed forces during World War II. Ken Davison poses for a photograph while on leave from his unit. (Courtesy of the Lorraine Applegate collection.)

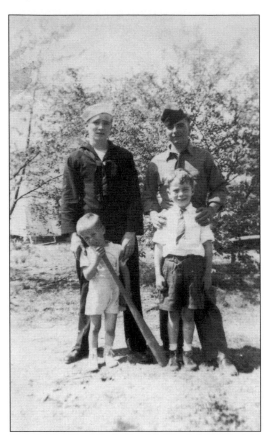

Like every large city and small town in America, Jackson residents honorably served the United States during World War II. In this photograph, American soldiers serving in two branches of the armed forces pose prior to being deployed overseas. Pictured are, from left to right, (first row) Borden Applegate and Ronnie Applegate; (second row) Robert Schuster and Kingsley Davison. (Courtesy of Lorraine Applegate.)

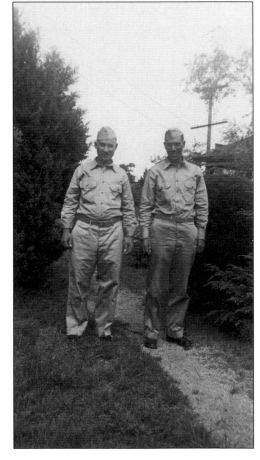

During World War II, every American community sent soldiers to war. Like the soldiers in this photograph, most Jackson residents enlisted in the US Army. Pictured are, from left to right, soldiers Orville Davison and Ken Davison. (Courtesy of Lorraine Applegate.)

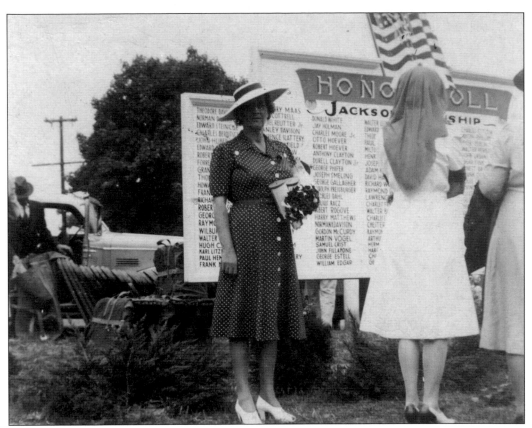

Alice Slattery attends the 1943 dedication of the Jackson Honor Roll, recognizing Jackson residents who served in the armed forces. The sign was a source of pride for Jackson residents for decades but eventually succumbed to the elements. (Courtesy of the Lorraine Applegate collection.)

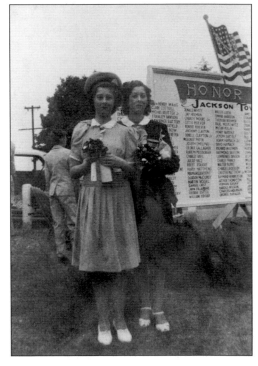

Lorraine Applegate poses with Jean Slattery in front of the Jackson Honor Roll sign that recognized those who had served or were serving in the military during World War II. Township residents gathered for the ceremony dedicating the sign in 1943. The Jackson Honor Roll sign stood at the intersection of Bennett Mills Road and East Veterans Highway. (Courtesy of the Lorraine Applegate collection.)

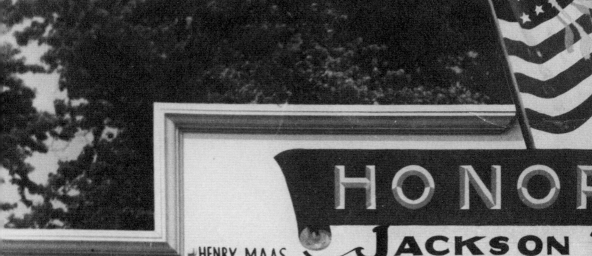

HO NOF

JACKSON

THEODORE DAVISON
NORMAN DAVISON
EDWARD STEINICKE
CHARLES DERDITSCH Jr.
JOHN HUBER
EDWARD HUBER
ROBERT MARTIN
FORREST IRLAND
GRANDIN THOMPSON
THOMAS LaBARRIE
HOWARD TAYLOR
FRANCIS TAYLOR
RICHARD TAYLOR
ROBERT GIBSON
GEORGE GIBSON Jr.
RAYMOND GIBSON
WILBUR BAILEY
WALTER GREGARSKI
HUGH C. HILD
KARL LITZENBERGER
PAUL HENDRKKSON
FRANK NASTO

HENRY MAAS
CLARK COTTRELL
MICHAEL REUTTER Jr.
STANLEY DAVISON
LAWRENCE SLATTERY
RUSSELL MAXFIELD
HORACE DOLBOW
STANLEY WERETKA
JAMES BURKE
RAYMOND HALL
CHARLES BOEHMER
THOMAS BOEHMER
WILSON PATTERSON
LEON ARCHER
HAROLD BENSON
FRANKLIN MATTHEWS
JOSEPH HOGAN
RUSSELL BAILEY
HENRY HAHN
WERNER STURM
JAMES EVERETT
ERNEST SLATTERY
LOUIS CRIST

DONALD WHITE
JAY HOLMAN
CHARLES MOORE Jr.
OTTO HOEVER
ROBERT HOEVER
ANTHONY CLAYTON
DURELL CLAYTON Jr.
★GEORGE PHIFER
JOSEPH SMELING
GEORGE GALLAGHER
RUDOLPH PRESSBURGER
CHARLES DAHL
JULIUS RACZ
ROBERT ROGOVE
HARRY MATTHEWS
NORMANKDAVISON
GORDON McCURDY
MARTIN VOGEL
SAMUEL CRIST
JOHN FILLAPONE
GEORGE ESTELL
WILLIAM EDGAR

WALTER LUKER
EDWARD ANDERSON
THEODORE BOEHMER
PAUL MOSKOWITZ
MILTON PERLIN
HENRY BARTOLF
JOSEPH BARTOLF
ADAM HAYBACH Jr
DAVID HAYBACH
RICHARD WISEMEN
RAYMOND DAVISON
LAWRENCE DAVISON
CHARLES FRANCIS
WALTER BURKE
CHARLES E. ANDERSON
CHESTER MATTHEW
RAYMOND HENDRICKSO
ARTHUR THOMPSON
HERMAN EDGAR
HAROLD WILSON
CHARLES ANDERSON
GEORGE BARALUS

Many of the Jackson residents who served the United States during World War II were recognized in the Jackson Honor Roll, which was displayed in the center of town. The sign, erected in 1943, honored the young men who fought overseas and offered prayers for their safe return. The war

122

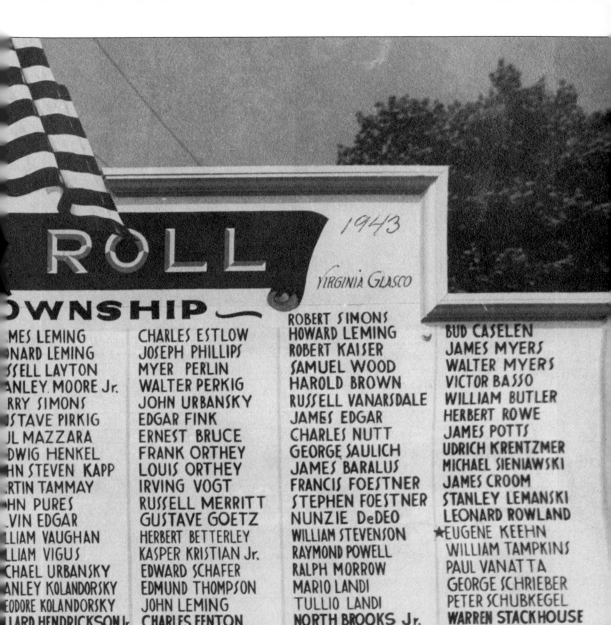

ROLL

1943

Virginia Glasco

OWNSHIP

MES LEMING	CHARLES ESTLOW	ROBERT SIMONS	BUD CASELEN
NARD LEMING	JOSEPH PHILLIPS	HOWARD LEMING	JAMES MYERS
SSELL LAYTON	MYER PERLIN	ROBERT KAISER	WALTER MYERS
ANLEY MOORE Jr.	WALTER PERKIG	SAMUEL WOOD	VICTOR BASSO
RRY SIMONS	JOHN URBANSKY	HAROLD BROWN	WILLIAM BUTLER
STAVE PIRKIG	EDGAR FINK	RUSSELL VANARSDALE	HERBERT ROWE
L MAZZARA	ERNEST BRUCE	JAMES EDGAR	JAMES POTTS
DWIG HENKEL	FRANK ORTHEY	CHARLES NUTT	UDRICH KRENTZMER
HN STEVEN KAPP	LOUIS ORTHEY	GEORGE SAULICH	MICHAEL SIENIAWSKI
RTIN TAMMAY	IRVING VOGT	JAMES BARALUS	JAMES CROOM
HN PURES	RUSSELL MERRITT	FRANCIS FOESTNER	STANLEY LEMANSKI
VIN EDGAR	GUSTAVE GOETZ	STEPHEN FOESTNER	LEONARD ROWLAND
LIAM VAUGHAN	HERBERT BETTERLEY	NUNZIE DeDEO	★EUGENE KEEHN
LIAM VIGUS	KASPER KRISTIAN Jr.	WILLIAM STEVENSON	WILLIAM TAMPKINS
CHAEL URBANSKY	EDWARD SCHAFER	RAYMOND POWELL	PAUL VANATTA
ANLEY KOLANDORSKY	EDMUND THOMPSON	RALPH MORROW	GEORGE SCHRIEBER
EODORE KOLANDORSKY	JOHN LEMING	MARIO LANDI	PETER SCHUBKEGEL
LLARD HENDRICKSON Jr.	CHARLES FENTON	TULLIO LANDI	WARREN STACKHOUSE
STER GRANT	A. JACKSON HURLEY	NORTH BROOKS Jr.	NEIL WILCOX
HN COTTRELL	JOHN STAMOS	MICHAEL LANDI	JOHN SCHALLER
NNETH THOMPSON	Wᵐ HUTCHINGS	WILLIAM FORSTNER	PETER MARIN
ROLD POWELL	HERBERT CLUGE	LOUIS DEMETRY	CHARLES HESS
		WILLIAM YOUMANS	

lasted two more years, and many additional Jackson residents answered the call. (Courtesy of the Lorraine Applegate collection.)

Total victory in World War II required a total effort from every American, and American women played key roles that supported the Allied victory. Shown here is a group of military nurses from Jackson. Lillian Davison is pictured at far left. (Courtesy of the Lorraine Applegate collection.)

Although not everyone was old enough to comprehend the reason for the celebration, every US citizen seemingly participated in the national sense of relief and jubilation with word of Japan's surrender in World War II. Photographed here on V-J Day, young residents in Jackson are eager to join a parade celebrating the end of World War II. (Courtesy of the Lorraine Applegate collection.)

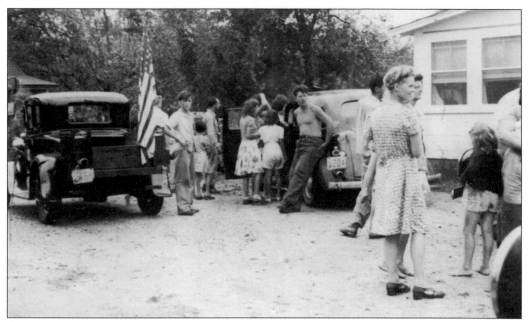

After being engaged in a brutal war for four years, the United States achieved victory in the Pacific on August 14, 1945. While millions of Americans celebrated across the country, Jackson residents organized their own small-scale parade. This photograph was taken in front of the Applegate General Store. (Courtesy of the Lorraine Applegate collection.)

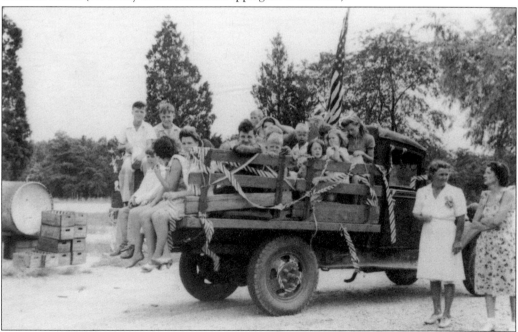

After several years of conflict, the nation experienced a sense of relief as Japanese forces surrendered to the Allies on August 14, 1945, which would become known as V-J Day. A sense of jubilation accompanied the relief Americans felt, and spontaneous celebrations broke out from coast to coast. Jackson residents began their V-J Day parade by leaving the lot adjacent to the Applegate General Store. (Courtesy of the Lorraine Applegate collection.)

The Jackson Township World War II monument was erected in 1954 and placed outside of the old Jackson Police Station. The monument has since been relocated to the Jackson Justice Complex. (Courtesy of the Jackson Township Historic Commission.)

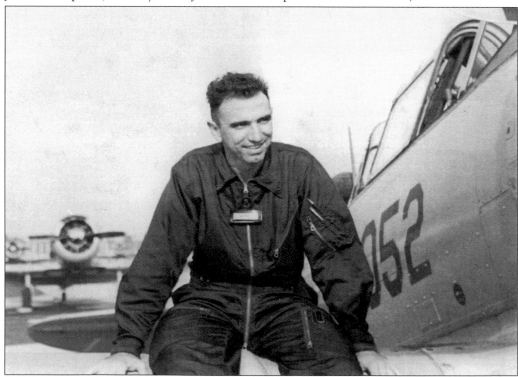

Lifelong Jackson resident Frank Holman served in the US Air Force during the Korean War. Holman's combat résumé includes the Combat Readiness Medal and the National Defense Service Medal. After the war, Holman remained in the Air Force for more than three decades, retiring from the ranks as a brigadier general in the Air Force Reserve. (Courtesy of the Holman family.)

Born in Jackson in 1926, Gene L. Hendrickson was a longtime resident, attending a one-room schoolhouse in town through grade eight and was a member of the Lakewood High School class of 1944. He left high school to enlist in the US Marine Corps where he served overseas in the Pacific theater during World War II. Upon his return from the war, he became involved in veteran's affairs, serving as commander of the Jackson VFW 4703 and Ocean County commander VFW 1959. From 1948 to 1985, Hendrickson operated Gene's Photo and Sports Center in Lakewood. (Courtesy of Gene Hendrickson.)

Gen. Frank Holman enjoyed a lengthy career of public service to the United States and to Jackson Township. In addition to Holman's 37-year Air Force career, which included a tour of duty in the Korean War, the lifelong township resident was also much engaged in politics and community service. Holman served as Jackson mayor from 1960 to 1964 and was a longtime volunteer in the Whitesville Fire Department. After a stint as Ocean County administrator from 1977 to 1982, Gov. Tom Kean named Holman chairman of the Republican State Party and he held that position until 1988, when Kean tapped him to be the executive director of the New Jersey Turnpike Authority. Holman passed away in 2005 at the age of 75 and was given full military honors upon being laid to rest in St. Mary's Cemetery in Lakewood. (Courtesy of the Holman family.)

DISCOVER THOUSANDS OF LOCAL HISTORY BOOKS FEATURING MILLIONS OF VINTAGE IMAGES

Arcadia Publishing, the leading local history publisher in the United States, is committed to making history accessible and meaningful through publishing books that celebrate and preserve the heritage of America's people and places.

Find more books like this at
www.arcadiapublishing.com

Search for your hometown history, your old stomping grounds, and even your favorite sports team.